IMAGES
of America

SOUTHOLD

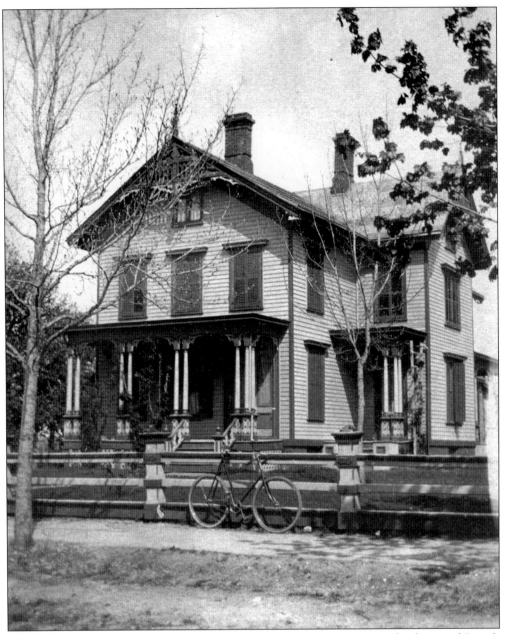

THE J. H. HORTON HOUSE, 1898. This grand Victorian house was the home of Joseph Hazzard Horton (1796–1881) and his wife, Mehitabel Horton (1796–1878). It was built in 1878 on the corner of Hortons Lane and Main Street, the site of the old Barnabas Horton House, which was demolished earlier that year. The house later became the home of David Philander Horton (1827–1902), a noted musician and composer.

IMAGES
of America

SOUTHOLD

Geoffrey K. Fleming

ARCADIA

First published 2004

Published by Arcadia Publishing
Charleston SC, Chicago IL, Portsmouth NH, San Francisco CA

Printed in Great Britain

Library of Congress Catalog Card Number: 2004102939

For all general information, contact Arcadia Publishing:
Telephone 843-853-2070
Fax 843-853-0044
E-mail sales@arcadiapublishing.com
For customer service and orders:
Toll-free 1-888-313-2665

Visit us on the Internet at www.arcadiapublishing.com

On the cover: **LUNCH AT THE BEACH.** Valerie Underwood works to prepare some lunch at Cedar Beach in Southold *c.* 1905.

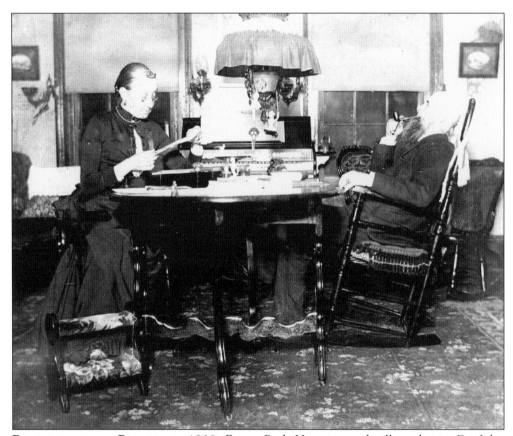

RELAXING IN THE PARLOR, c. 1900. Emma Peck Huntting and village dentist Dr. John Green Huntting relax in the parlor of their home, located facing the head of Oaklawn Avenue.

CONTENTS

ACKNOWLEDGMENTS

This book is the first to showcase some of the extensive collection of photographic images held by the Southold Historical Society. Over the years, many different donors have presented a varied array of images to the society. Their generous donations are the only reason this book was made possible.

There are literally thousands of images that could have been used in this book, but space was available for only about 200. This book is not meant to be a complete guide to all images captured by photographers who lived in or visited Southold. It is merely meant to be a slice of 350-plus years of history, a brief look of what Southold was like in the past. This book includes a number of images from Peconic and Arshamomaque because of their close proximity and strong connections to Southold, although the primary focus is on Southold village. The majority of images date from the period 1865 to 1965.

A publication such as this one relies on the work of many different volunteers at the historical society, as well as devoted and interested members of the public. Although the majority of the images came from within the historical society, a good deal of previously unrecorded information came from outside of it. Thanks go to Herb Adler, Bill Albertson, Clara Bjerknes, Ed and Whitney Booth, Pat Milford, Peggy Murphy, Carol Cosden Price, Bob Pettit, Jim Rich, and all those here unnamed who helped to clarify the research used to create this book.

Special thanks go to the Southold Free Library's Whitaker Collection and its manager, Vanessa Patterson, for two images that were used in this book (facade of Old St. Patrick's and the Southold Railroad Station) and for help in editing the text and finding some facts that were not easy to discover.

Should you have photographic images of houses, businesses, events, people, or places in Southold, please consider sharing them with the historical society, which can be reached by mail at Southold Historical Society, P.O. Box 1, Southold, NY 11971 or on the web at www.southoldhistoricalsociety.org.

—Geoffrey K. Fleming, Director
Southold Historical Society

INTRODUCTION

Southold is the oldest English settlement in the state of New York, although the town of Southampton maintains that it is. Both communities can equally claim to have been founded by 1640, but only Southold can claim to have been settled earlier. It is clear from all the evidence that has surfaced in recent years that Southold's first European settlers were the Dutch, who apparently established lumber outposts on far-eastern Long Island as early as the 1630s. The Dutch influenced Southold's early history until 1674, when a small force arrived, demanding allegiance to the Dutch Republic after the recapture of New York. This force was repelled, and thus ended any further European influence other than that of England.

Southold hamlet, along with its smaller surrounding villages, was and still is agrarian in nature. The small family farm was the norm in Southold for generations, with the same ancient families intermarrying and keeping their holdings within recognized familial relationships. There was one church (Congregational) that served the community, although the Quakers were present in Southold from an early date.

In the 19th century, all this began to change. The Methodists, Universalists, and Catholics established their own houses of worship in Southold. The ancient Congregational church joined the Long Island Presbytery and ended nearly two centuries of independence.

New residents from other states and regions began arriving in larger numbers, establishing themselves on land long occupied by descendants of the hamlet's original founders. By the mid-19th century, Connecticut natives like Israel Peck had arrived, building large houses along Main Road to display their wealth and position to the community. The railroad, which first began running in the 1840s, made accessing Southold and other local communities easier and quicker than anyone ever thought possible.

Irish and German immigrants, escaping famine and unforgiving foreign governments, followed newcomers like Peck, first laboring on the farms and later buying up land. Families with names such as Coles, Conway, Feeney, Karcher, Kochendaffer, and Probst brought new ideas and new traditions to Southold.

They were followed by immigrants of Russian, Polish, and Lithuanian descent. Families with names like Akscien, Dubowik, Jarnecik, Jerodzik, Kotianski, Krukovsky, Nastolovitch, Polwado, Ruthkowksy, Stepnosky, Stignoski, and Surezensky began occupying much of the village farmland.

The 20th century saw many new business and services come to Southold. Electricity arrived in 1905 by way of the Southold Lighting Company. New retail stores dealing in groceries, pharmaceuticals, acetylene gas, and the shipping of produce thrived.

Summer visitors, mainly composed of Brooklyn society, made Southold their second home.

Boardinghouses and hotels flourished, as families traveled east to escape the summer heat of the city. Grand houses, many of which are now long demolished, dotted the countryside and coast, their owners attempting to create a summer colony like those on the South Fork of Long Island.

The year 1940 marked the 300th anniversary of the founding of the town and signified the beginning of a time of change and expansion for Southold. Old homes along Main Road were torn down for new, modern businesses. Farmland was sold for development, and a new breed of summer residents arrived.

Today, more than 350 years since the founding of Southold, much has changed; some change has been for the better, some for the worse. Regardless, Southold has continued to adapt to its changing environment and population, working hard to balance its historic past with its exciting future.

—GKF

One

LOCALES

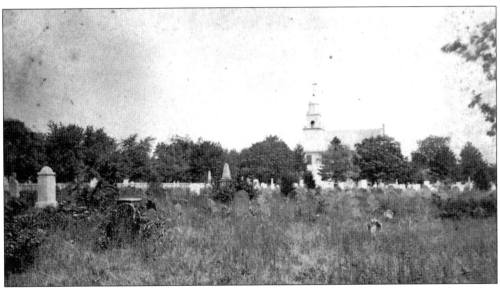

THE OLD SOUTHOLD CEMETERY, C. 1885. Every village has those out-of-the-way places that are neither inhabited nor abandoned. They are places that remind us of the past, of different times, and of the nature of the place in which we live. This is especially true of the streets and coastline that came to define Southold's character and rural nature. The following images are scenes that are sometimes non-specific, bringing together views of many different buildings, sites, or places that were important to the history and development of Southold. The Old Southold Cemetery, long associated with the Congregational church and its successor, the Presbyterian church, contains the earliest burials in Southold. The first meetinghouse stood along the road on what eventually became the cemetery grounds. The oldest part of the cemetery is known as God's Acre.

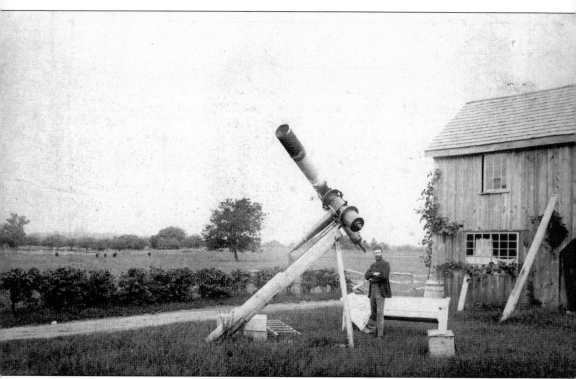

THE FITZ TELESCOPE, C. 1885. Henry Fitz Jr. (1808–1863) was born in Newburyport, Massachusetts. He later arrived in New York City and became interested in astronomy and optical instruments. By 1840, he had his own photography shop in Baltimore, and in 1842, returned to New York to devote his time to the manufacture of telescopes. After his death, his family moved to Peconic, where his wife had been raised. Here, son Henry Giles Fitz (1847–1939) stands by one of his father's telescopes in Peconic.

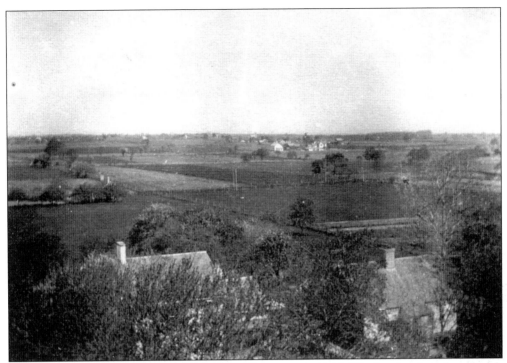

A VIEW FROM THE PRESBYTERIAN CHURCH STEEPLE, C. 1900. The landscape is dotted with small houses and agricultural complexes, and huge tracts of farmland fill out this view looking north. In the foreground are the homes of F. W. Tuthill and Mrs. N. W. Conklin. In the far right background are the farmhouse and barns of D. W. Grattan.

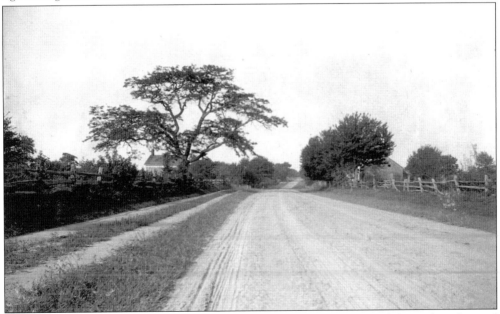

ON THE WAY FROM PECONIC TO SOUTHOLD, C. 1900. Typical split-rail fences line the road heading east along Route 25 from Peconic to Southold. Notice the walking and bicycle paths on the left side.

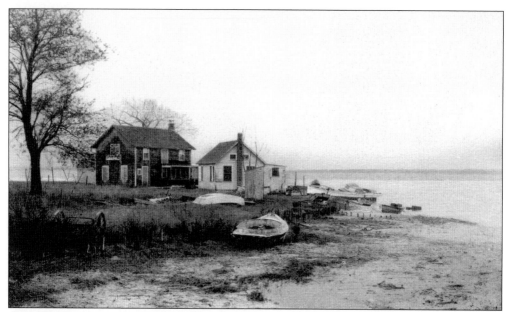

FOUNDER'S LANDING POINT, C. 1910. What is shown here is very different from what can be seen at Founder's Landing today. Here, small fishing shacks and abandoned boats litter the shore at the point. Today, this site is clear, with a massive cement retaining wall securing the coastline.

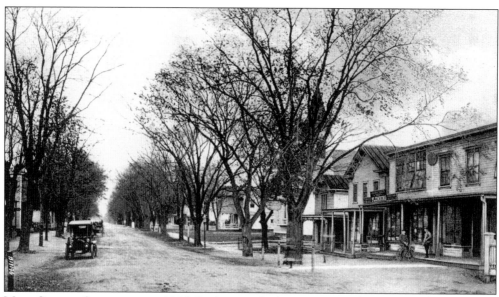

MAIN STREET, SOUTHOLD, C. 1915. In this view looking east toward Greenport, the south side of the street is dominated by W. H. Terry's Fire and Life Insurance offices and the Southold post office, followed by the new Methodist church and parsonage. Notice the acetylene gas lanterns along the street.

MAIN STREET, SOUTHOLD, C. 1915. Main Street is shown in this scene, looking west from the intersection of Youngs Avenue and Main Road. On the north side, the Southold Hotel can be seen, followed by the Henry W. Prince house and store. On the south side, the Van Deusen House, with its widow's watch, can be seen, followed by Howell's Drug Store.

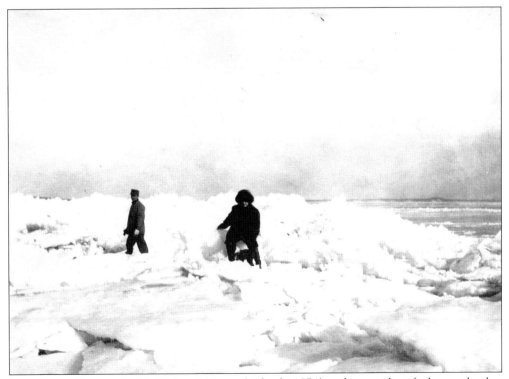

ICE ON THE BAY, C. 1920. Helen F. Byron (right, b. 1874) and an unidentified man clamber amidst the piles of ice that gathered along the bays and shores of Long Island each winter.

13

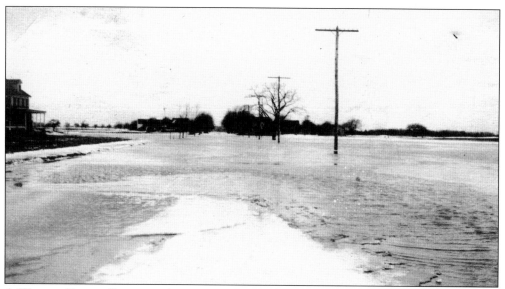

A WINTER FLOOD, BOISSEAU AVENUE, C. 1920. Flooding is a perennial problem in this area surrounded by flat farmland. Here, Boisseau Avenue disappears under the melting snow and ice.

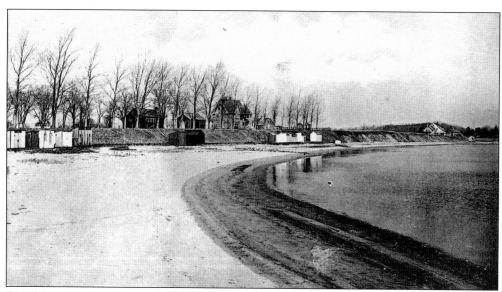

ON TOWN HARBOR, C. 1925. The bathing and changing houses that once dotted the beaches of Long Island are shown here not long before their demise. In the background on the bluff are the twin houses of J. B. Terry and the huge residence of Louise Ruebsamen Brown (1863–1953), known to everyone as "Mother Brown." Her son John P. "Nink" Ruebsamen (1895–1953) ran a real estate agency in Southold during the 1940s and 1950s.

Two

PEOPLE

**DR. JOHN GREEN HUNTTING,
C. 1885.** People are the lifeblood of
any community. They come into the
world, grow up, marry, have children,
work, rest, and eventually die. Each
person leaves a legacy to those who
follow, a history of their contributions
to the community. All played an
important part in the history of the
community, whether they were
businessman, farmers, teachers, or
laborers. This chapter contains a few
notes on some of the more prominent,
memorable, and interesting people who
helped define the history of Southold.
John Green Huntting (1838–1919) was
the son of Jonathan W. Huntting
(1812–1890) and Malvina Brown
Huntting (1806–1880). He was the
village dentist in the late 19th and
early 20th centuries, having his original
practice at 363 Canal Street in New
York City. He married Emma Peck
(1841–1924), daughter of wealthy
farmer Israel Peck (1814–1881).

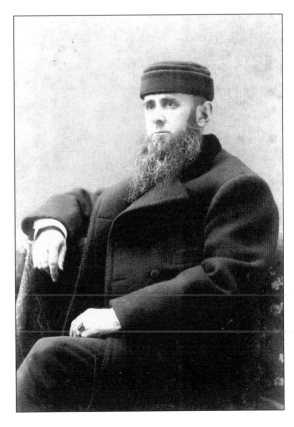

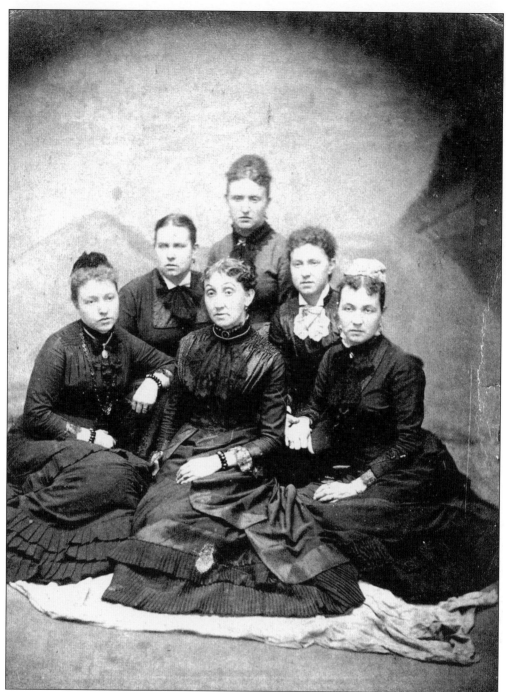

THE PECK SISTERS, C. 1885. Seated in all their glory, the mighty Peck sisters pose for a portrait at Warner's Studio in Sag Harbor. The daughters of wealthy farmer and horse track owner Israel Peck (1814–1881), they were married off to only the "first and best" of Southold. They are Caroline Peck Lowerre (1848–1926), Isabelle Peck Terry (1851–1929), Annie Peck Huntting (1846–1895), Emma Peck Huntting (1841–1924), Sarah Peck Wheeler (1843–1934), and Lucy Peck Conklin (1853–1934).

CAPT. CHARLES SANFORD, c. 1895. Relaxing at home, Charles Louis Sanford (1846–1928) reads a work by Rudyard Kipling, a great favorite of his. In his early years, Sanford commanded many cargo vessels for the marine firm of Nevin and Welch, including the bark *Prairie Bird* and the *Mastedon*. After retiring, he established a brick business in Northport, and then in 1889, came to Southold and purchased the small works of David Graham, renaming it the Arshamomaque Brick Works. The business was located on Main Road east of the Old Barge restaurant. At the height of production, it produced 40,000 bricks per day.

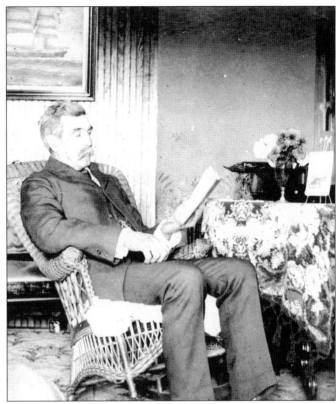

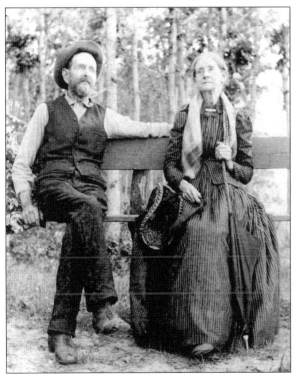

THEIR 50TH ANNIVERSARY, 1894. Joseph "Hull" Moore (b. 1818) and Sarah Case Moore (b. 1823) are depicted on their 50th wedding anniversary, a rare achievement in the 19th century. Together, they sit on a bench built between two trees. Sarah Moore holds her hat in one hand and her parasol in the other.

17

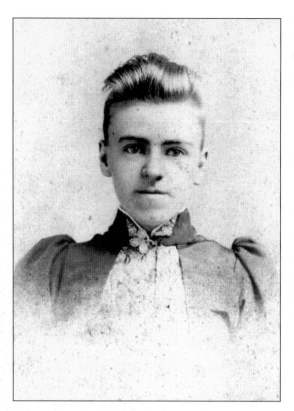

LUCY HALLOCK FOLK, C. 1889. Lucy Hallock Folk (1869–1946) was the sister of prominent newspaper owner Joseph N. Hallock (1861–1942). She is remembered as a champion of public libraries, having helped organize the Southold Free Library Association in 1904. She served as librarian from 1904 to 1909 and then as a trustee until the time of her death in 1946. The second-floor reading room in the library, which now holds the Whitaker Collection, was named in her honor.

ALVAH G. SALMON, C. 1892. Alvah Glover Salmon (1868–1917) was one of the village's noted composers. Born in Southold, he attended the New England Conservatory of Music and studied in both Germany and Russia. He traveled on extensive concert tours while also writing articles for musical magazines and lecturing on Slavonic music at Boston University, Wellesley, Vassar, and the Brooklyn Institute. He died suddenly at the age of 49 and is buried in the Presbyterian Cemetery.

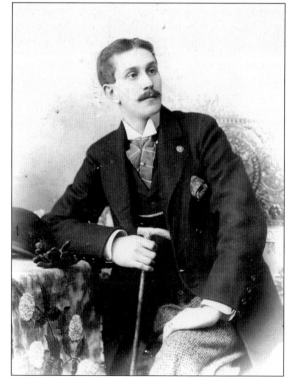

18

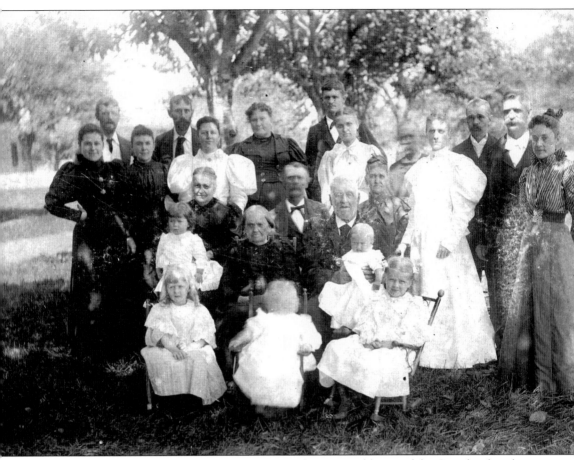

AT THE OLD PLACE, C. 1893. The Old Place was the ancestral home of the Case family, who owned it for many generations. Here, the extended family gathers on the grounds of the house. Present are Capt. Watts Overton, Jeanette Overton, Rosanna Overton Williams, Jerusha Overton Carpenter, Walter Carpenter, William Overton, Annie Overton, Fred Williams, Elsie E. Williams, Katherine Williams Case, Josiah C. Case, Henrietta Tuthill, Victor Overton, Jeannette Carpenter, Walter Carpenter, Sadie Carpenter, Annie Carpenter Matthews, A. D. Matthews, Margery Williams, Rosalind Case, Gladys Matthews, Gertrude Matthews, and Hazel Carpenter.

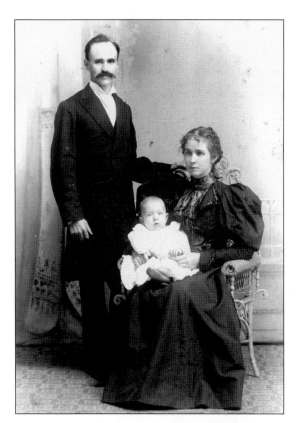

REV. FREEMAN AND FAMILY, C. 1895. Rev. James B. Freeman was appointed to succeed the Presbyterian minister, the Reverend George D. Miller, in 1895. Freeman is shown here with his wife and son.

REV. EPHER WHITAKER, C. 1895. One of the two longest-serving ministers at the Presbyterian church, Rev. Epher Whitaker (1820–1916) was minister from 1851 to 1892 and was pastor emeritus until his death. Born in New Jersey, he was well known for his research on the history of Southold. He was the author of several articles and books, including his *History of Southold, New Fruits from an Old Field,* and *Leaves of All Seasons.*

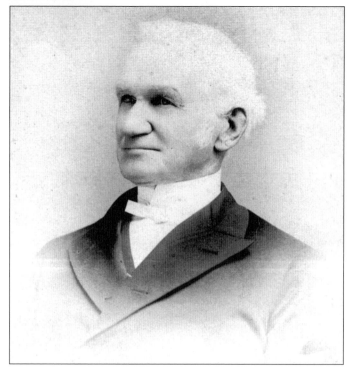

AMY H. STURGES, C. 1895.
Amy Horton Sturges (1876–1940) was the daughter of Richard Sturges (1847–1920) and Mary Tuthill Sturges (1852–1935). Her father was the village carpenter. The family lived and worked on property located at the corner of Oaklawn Avenue and Main Road in Southold.

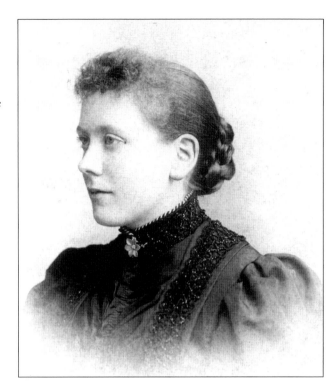

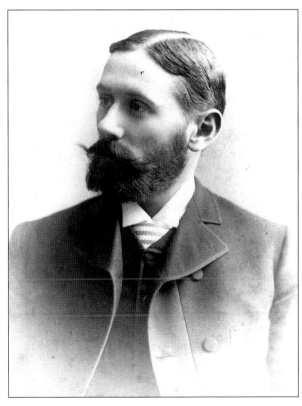

DR. JOSIAH C. CASE, C. 1896.
Josiah Corwin Case (1865–1930) was the son of Lewis R. Case (1820–1912) and Hannah Wells Case (b. 1828). He attended Cornell University and was trained as a veterinary surgeon. He served as a trustee of both the Peconic School and the Southold Savings Bank. He was widely known as a very skillful piano player and the owner of the Peconic Manufacturing Company, which produced Zincutta, a specialty cream used to heal burns, chafes, and other skin conditions.

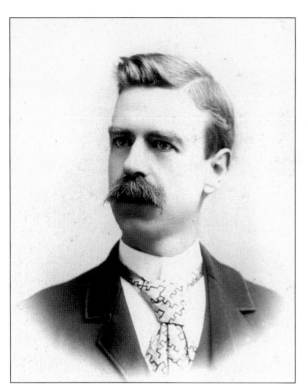

JOSEPH N. HALLOCK, C. 1897.
Born in Southold, Joseph Nelson Hallock (1861–1942) was the son of George Hallock (1821–1893) and Maria Jane Dickinson Hallock (1836–1925). Educated in the Southold schools, he was the owner and publisher of the *Traveler-Watchman* newspaper from 1889 to 1927. He went on to serve in a number of important positions: state assemblyman for three terms, Southold town clerk, Southold Savings Bank president, and Southold Board of Education president.

ELLA B. HALLOCK, C. 1900.
Ella Boldry Hallock (1861–1934) was born in Saratoga County. She was a teacher and educator, as well as an established author and editor. She worked with her husband, Joseph N. Hallock, running the *Traveler-Watchman* and writing numerous articles for local and metropolitan papers. The author of nine different books, she was the first American translator of *Grimm's Fairy Tales*. During the 1920s, she founded and was an ardent supporter of the little theater movement throughout Suffolk County.

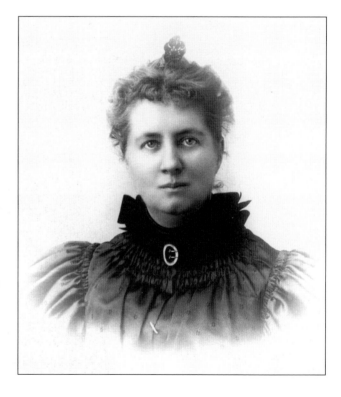

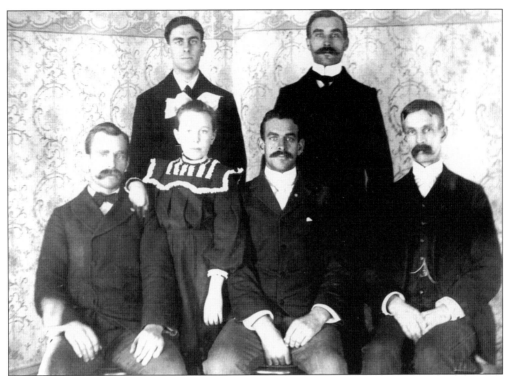

GILDER CONKLIN'S CHILDREN, C. 1900. Gilder S. Conklin (b. 1839) had a large farm on Main Road next door to G. H. Terry. Conklin's children—George (b. 1869), Fred (b. 1871), John (b. 1875), Grover (b. 1878), Ben, and Mary Hallock Conklin—are pictured here in all their Sunday finery.

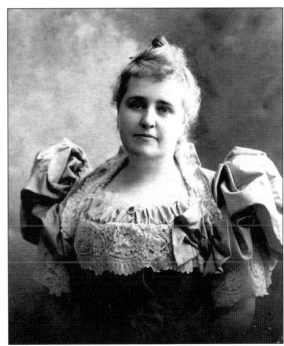

SUSAN M. JOOST, C. 1900. Born in Ohio, Susan M. Joost (1851–1927) was the wife of W. H. Joost (1846–1919), an insurance company executive from Brooklyn. The Joosts lived on Dean Street in Brooklyn and had a house on the east side of Maple Lane in Southold.

23

WILLIAM H. JOOST, C. 1900. William H. Joost (1846–1919) was raised in Brooklyn and began his working life as a cashier. By the late 19th century, he was an important businessman, having become a director of the Metropolitan Plate Glass Insurance Company of Brooklyn. Joost served as a member of the audit committee for Southold's 275th anniversary celebration, held in 1915.

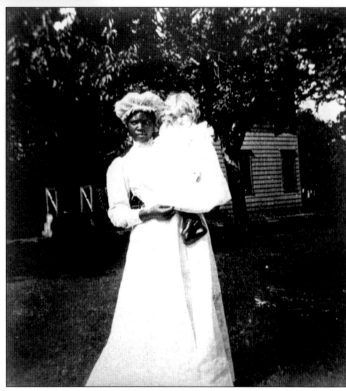

FRIEDA WILLIAMS AND HER NANNY, C. 1902. Frieda Williams (right, b. 1901) was the daughter of local grocer Frederick C. Williams (1867–1908) and Elsie E. Williams (1869–1934). She is pictured early in the 20th century with her nanny.

REV. W. H. LLOYD, C. 1905. The Rev. William Huntley Lloyd (1862–1935) was born in Wales, Great Britain. He trained at several schools, including Lafayette College in Pennsylvania and the Lane Theological Seminary. He began his position at the Presbyterian church in 1897 and served until May 1935, when he died suddenly following an automobile accident. His pastorate of 38 years was second only to that of Rev. Epher Whitaker.

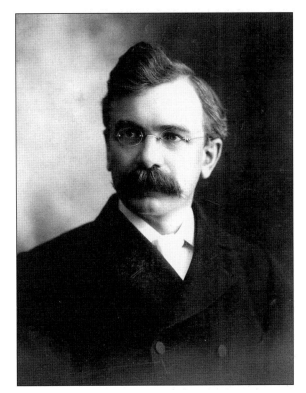

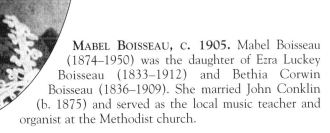

MABEL BOISSEAU, C. 1905. Mabel Boisseau (1874–1950) was the daughter of Ezra Luckey Boisseau (1833–1912) and Bethia Corwin Boisseau (1836–1909). She married John Conklin (b. 1875) and served as the local music teacher and organist at the Methodist church.

**CARL HILER AND HIS SIBLING,
c. 1905.** Carl Hiler (left) is dressed in
a sailor suit, the most popular form of
clothing for young boys during the
Victorian era. He was the son of the
Reverend Henry F. Hiler (b. 1871), the
Methodist church minister from 1899
to 1901 and the president of the
Southold Tennis Club.

RENSSELAER G. TERRY SR., c. 1905.
Rensselaer Goldsmith Terry (1887–1951)
was the son of George Chaplain and
Elizabeth Bunce Terry. He attended the
Southold public schools and St. Lawrence
University. He began his career at the Southold
Savings Bank as a clerk and progressed to become
treasurer and eventually vice president in 1942.

BELLE F. HADLEY, c. 1906.
Proudly seated, Belle Fithian Hadley (1865–1930) was the wife of Robert Hadley, the owner of the Village Livery Stable in Southold. Her family lived on the south side of Main Road in the Thomas Moore House, which is today owned by the Southold Historical Society.

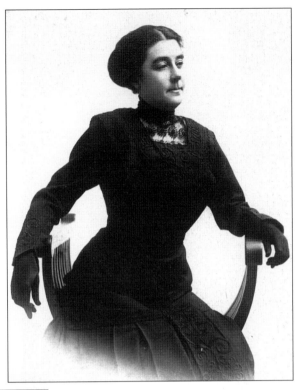

THE CASE SISTERS, 1906. Marion Terry "Mammie" Case (1877–1929) and her sister Fannie I. Case (1871–1922) are pictured in Southold. Both were noted seamstresses, and Fannie Case worked for a time at Frank Smith's Millinery Shop in Peconic. The sisters traveled extensively in America and Europe.

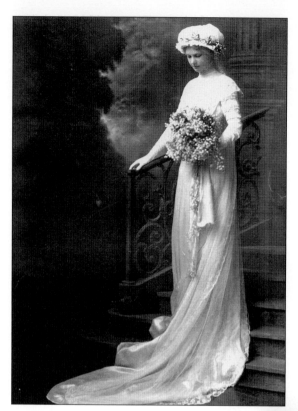

THE WEDDING DRESS, 1911. Gladys Matthews Mott (1889–1994) poses in her magnificent wedding gown, which, today, is in the collection of the Southold Historical Society. This portrait was taken on August 12, 1911, the day she married Stanton Mott (1888–1969). The Motts summered in Southold and built a summer home on South Harbor Road in 1925.

THE DIETZ GIRLS, 1914. Sisters Marguerite (b. 1893) and Cissy (b. 1894) Dietz are pictured in their winter outfits. The Dietz family lived on Peconic Lane and worked on the farm of Silas Overton, in Peconic. The father, Joseph Dietz, arrived here from Germany in 1889. Marguerite later married Charles Turner of Southold, and Cissy married Alfred Davids of East Cutchogue.

MARY L. DAYTON, 1915. Dressed in period style for Southold's 175th anniversary celebration, Mary Landon Dayton (1873–1956) sits in a photographer's studio, probably in Greenport. She was one of the last descendants of her line, being directly related to both Barnabas Horton, a first settler, and Nathan Landon, a second-generation settler. She lived in Robins Hollow, her ancestral home in Bayview.

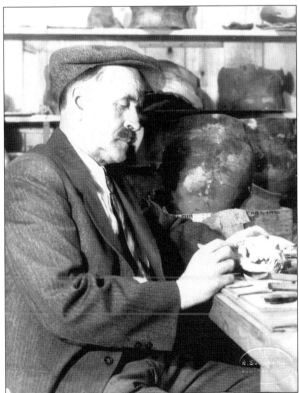

NATHANIEL BOOTH AT WORK, 1940. Nathaniel E. Booth (b. 1873) works on one of his hobbies, studying Indian artifacts, at the Custer Institute. His other great activity was his service as chief of the Southold Fire Department from 1914 to 1936, the longest service (22 years) of any chief in the department's history.

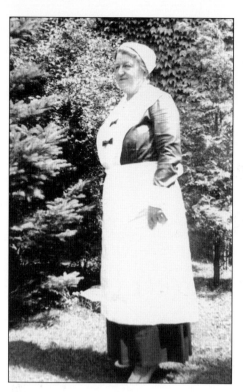

DRESSED FOR THE TERCENTENARY, 1940.
Loraine Barry Cosden (1884–1950) is pictured dressed up for the Southold tercentenary, in 1940. She was the wife of Alfred H. Cosden (1873–1962), a former drug executive who owned a large estate named Eastward on Soundview Avenue. She was very active in working with charitable organizations, both in Southold and in New York City.

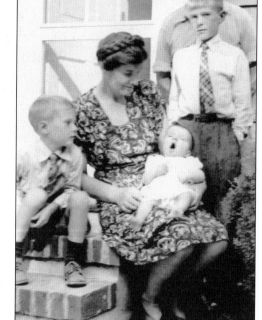

THE ANDREASEN FAMILY, C. 1950.
Henry Andreasen was the superintendent of Lighthouse Farm, on Pine Neck Road, during the ownership of Leo Roon, which lasted from 1943 to 1955. He is pictured with his wife and three children.

Three

CHURCH
AND COMMUNITY

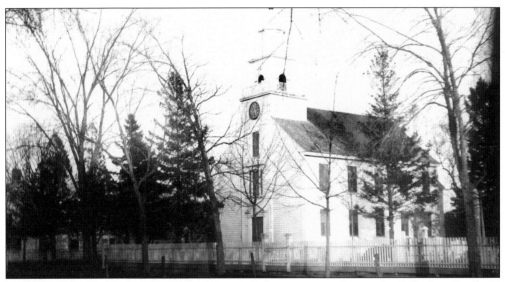

THE FIRST PRESBYTERIAN CHURCH, C. 1890. Religion was on the minds of all when Southold was founded. The Congregational church was the first to serve the hamlet and did so nearly single-handedly for more than 150 years. In the 19th century, Methodists, Universalists, and Catholics established their own churches and community support groups. Local clubs and organizations formed to support and protect the community, including the Grange, Tuesday Morning Club, Southold Free Library, and fire and police departments. Special events, as well as disasters, brought the community together many times, although few events were as strongly uniting as the 1940 tercentenary. The First Presbyterian Church's third building was constructed in 1803 to replace the second meetinghouse. It was the last of three buildings, the first serving from 1640 to 1684 and the second from 1684 to 1803. As in most places on eastern Long Island, the church was originally Congregational and only later joined with the Presbytery of Long Island. The steeple was added in 1808, and the clock—a gift of Thomas Lester (1811–1885)—was installed in 1884.

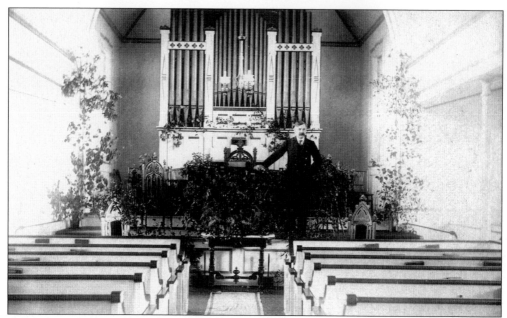

THE INTERIOR OF THE FIRST PRESBYTERIAN CHURCH, C. 1910. Rev. William H. Lloyd (1864–1935) stands at the altar of the Presbyterian church (third building), with its massive Victorian pipe organ in place. The ornamental sprigs of flowers and vines were a popular decorative device in the late 19th and early 20th centuries.

THE METHODIST CHURCH, C. 1890. Like the Presbyterian church, the Methodist church in Southold has had three buildings. Until 1818, the congregation met in local homes, and in that year a small chapel was erected on the corner of Main Road and Boisseau Avenue to accommodate the growing membership. The second church, shown here, was erected in 1851 and served until 1898, when it was damaged and replaced by the present and third church.

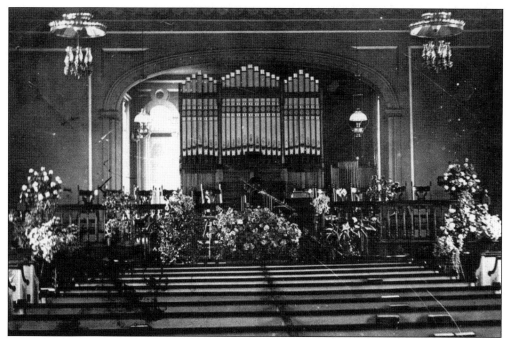

THE INTERIOR OF THE METHODIST CHURCH, C. 1891. A huge, recently installed Victorian organ dominates the arch in which the altar of the second church sat. Installed in 1876, the hanging acetylene gas chandeliers, topped with large reflectors, provided the dark interior much needed light during evening services.

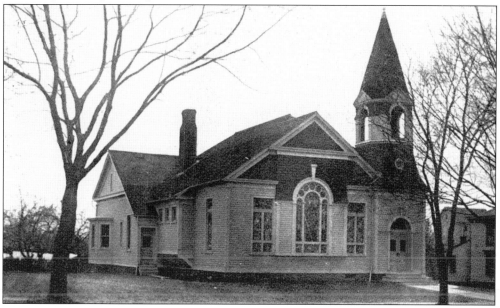

THE NEW METHODIST CHURCH, 1909. In 1898, the steeple of the second church was destroyed by a winter storm. Afterward, the congregation decided to build a new church rather than repair the old one. A New York City architect provided the plans, and J. E. Corey was selected as the builder. The new structure, the third, was built on Main Road opposite Beckwith Avenue and was dedicated on June 10, 1900.

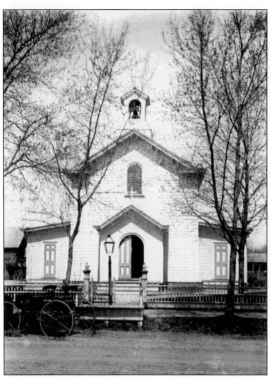

THE OLD ST. PATRICK'S CHURCH, THE 1890s. Located opposite the Presbyterian church on Main Road, St. Patrick's was housed in the renovated Southold Collegiate Institute building and opened for services in 1864. The church remained in this building until 1927, when the new St. Patrick's was opened farther west on Main Road. The old church remained on Main Road until 1946, when it was sold and disassembled to be erected as a house on Sound Avenue.

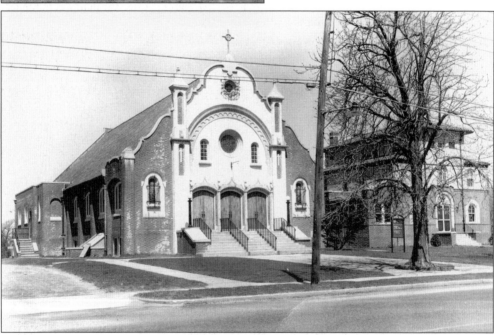

THE NEW ST. PATRICK'S CHURCH, 1957. By the 1920s, the old St. Patrick's had become far too small to accommodate the growing parish. A new church, designed in a Mediterranean Revival style, was built nearly opposite the Universalist church on Main Road in 1927 and was dedicated the same year by Bishop Thomas E. Molloy (1884–1956). Construction work included a new rectory, shown on the right.

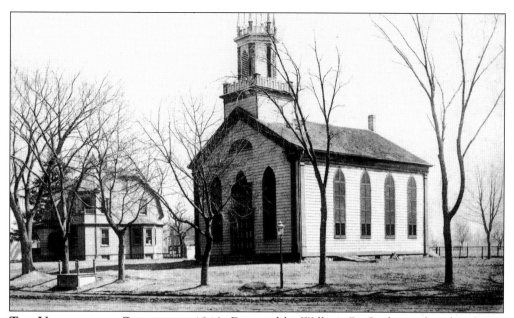

THE UNIVERSALIST CHURCH, C. 1910. Designed by William D. Cochran, this church was erected in 1837. It welcomed all people who "openly acknowledge the Universality of the Grace of God." The structure was topped by a magnificent steeple finished by a series of Gothic pinnacles, and the interior was one large open space. The parsonage, on the left, was constructed in 1902, followed by a parish house a few years later. Notice the platform in the left foreground that used when entering or exiting a carriage.

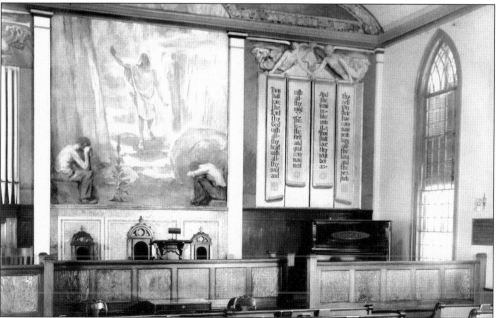

THE INTERIOR OF THE UNIVERSALIST CHURCH, 1935. This view was taken at the time of the 100th anniversary of the founding of the church. The elaborate painting is by Edith Mitchell Prellwitz (1864–1944). It was donated in 1926 in memory of the artist's parents. The pipe organ, partially visible on the left, was installed in 1920.

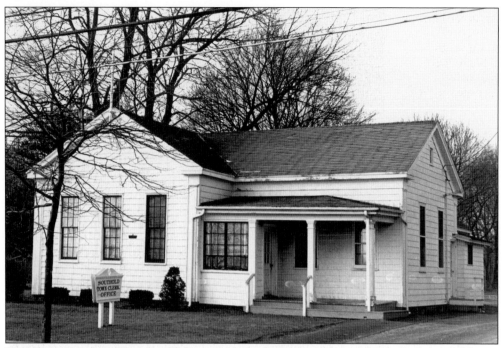

THE PRESBYTERIAN CHAPEL (TOWN CLERK'S OFFICE), C. THE 1960S. Built in 1794 as a school, the building was heavily reconstructed in 1844. In 1870, the school closed and the building became the Presbyterian chapel. It remained a chapel until 1952, when the building was acquired to house the town clerk's office. It was later moved from Main Road to Traveler Street, where it stands today.

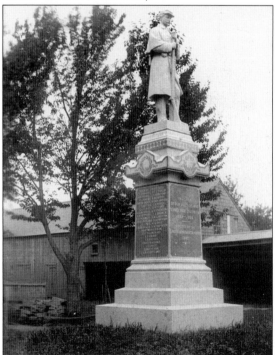

THE CIVIL WAR MONUMENT, c. 1890. Erected to honor the memory of soldiers from Southold who fought for the Union, the monument stands at the ntersection of Main Road and Tuckers Lane. It was erected through the efforts of the Ladies Monumental Union in 1887. In the background are the barns (now gone) of Jonathan W. Huntting (1812–1890).

BELMONT HALL, c. 1900. Located on the south side of Main Street diagonally opposite the First Savings Bank (now the library), Belmont Hall set the pace for public entertainment in Southold during the late 19th and early 20th centuries. Many plays and theatricals were held here, as were public meetings and the first movies. Belmont Hall was razed for a parking lot in 1954.

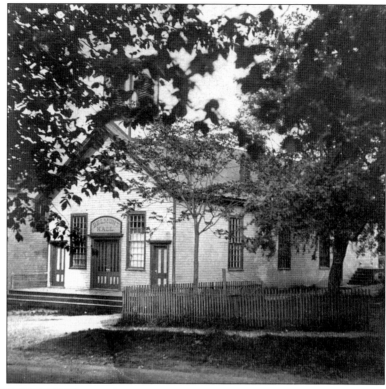

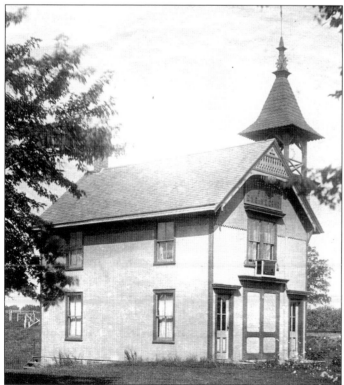

THE PROTECTION ENGINE COMPANY NO. 1, c. 1900. Located on the northwest corner of Beckwith Avenue and Traveler Street, the Protection Engine Company No. 1 was organized in 1886 as one of two engine companies, the other being the Eagle Hook and Ladder Company, which served Southold. The building shown here was built in 1888 and used until 1937, when the new firehouse was completed. That year, the old building was sold to the Southold Grange. In recent decades it served as the Church of the Open Door and as an office.

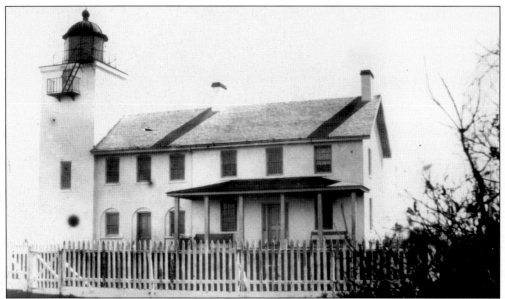

THE HORTON POINT LIGHTHOUSE, C. 1900. Constructed by the U.S. Coast Guard in 1857, the lighthouse saw continuous operation until 1933, when it was decommissioned and replaced by a skeletal light tower. The Southold Park District purchased the old lighthouse building and land in 1934 and preserved the area as a park. In 1990, a massive restoration effort resulted in the recommissioning of the light in the lighthouse and the removal of the skeletal light. Today, the lighthouse building is operated as a nautical museum.

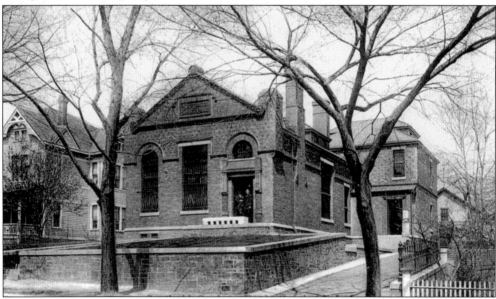

THE SOUTHOLD LIBRARY (CAHOON MEMORIAL BUILDING), 1915. Constructed as offices for the Southold Savings Bank in 1891, the building was left empty when the bank moved to a new structure on the corner of Main Road and Youngs Avenue in 1927. The old building was purchased by Edna Cahoon Booth (1899–1964), who presented it to the library in memory of her parents, Edward Daley and Georgia Rockwell Cahoon. The Southold Free Library moved into the building in 1928. The Lewis (Cochran) House is on the left.

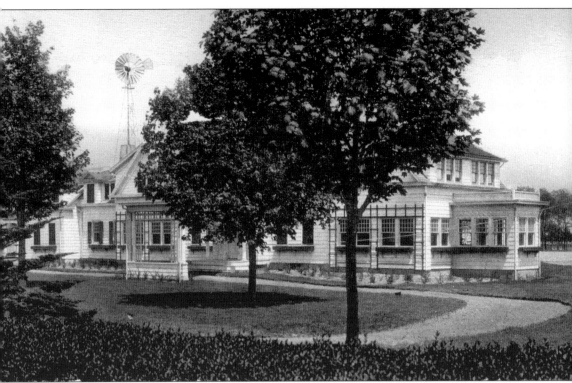

THE COUNTRY CLUB, SOUTHOLD, 1923. Established by noted attorney and golf course developer Edwin H. Brown (1851–1930), the club was first located in Bayview. After the site was selected, an old house on the property was renovated as a clubhouse, as shown here. Not long before the golf course was to be laid out, another site, more suitable to golfing, came up for sale nearby. The club purchased the new site, built a new clubhouse, and took the name Reydon Country Club. The club went bankrupt in 1939, and the property was developed for housing. The original clubhouse, located in the 1926 Cedar Beach Park subdivision, became a restaurant named the Cedar Beach Inn, later known as the General Wayne Inn. Today, the building lies in a sad state of ruin.

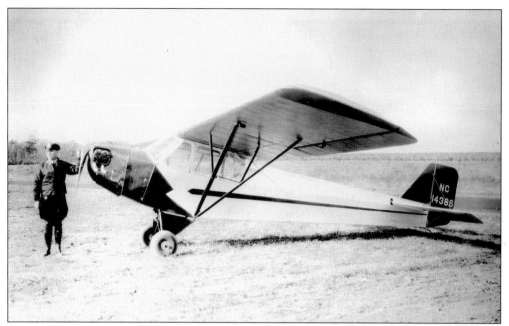

THE FLYING POLICE, 1937. Probably very few residents realize that the Southold police force actually had its own aerial division at one time. Here, peace officer James "Pat" Kelly (b. 1902) shows off the town's plane. Kelly was hired as the first uniformed peace officer for the town of Southold in 1928, replacing the old non-uniformed constables, who had long served the community. The police department, as people know it today, was organized in 1960.

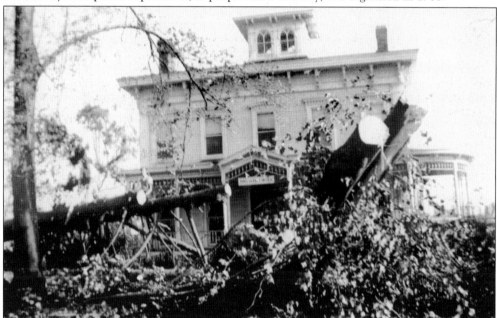

THE HURRICANE OF 1938. The worst hurricane ever to strike Long Island occurred in September 1938. Heavy rains in the days before the storm left large trees vulnerable to the hurricane winds, which easily uprooted them, causing immense damage. Pictured surrounded by downed trees is the Albertson House, which was serving as the town clerk's office.

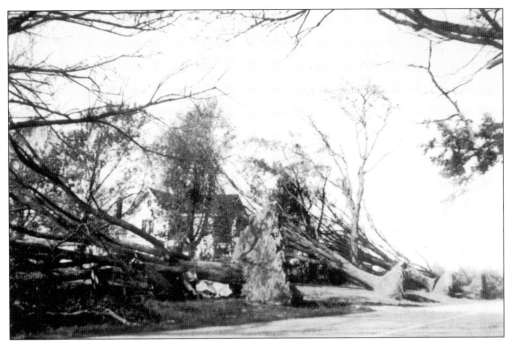

AFTER THE HURRICANE OF 1938. Planted through the efforts of wealthy resident Israel Peck (1814–1881), the great trees that once lined Main Road lie toppled over.

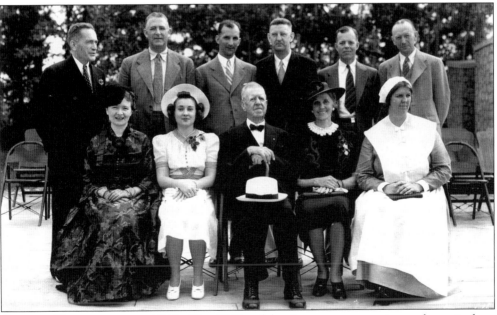

AT THE TERCENTENARY, 1940. The 1940 celebrations were extensive and required an organized general committee to help make things happen. On stage are, from left to right, the following: (first row) Constance L. Kendrick, Jean Hallock, J. N. Hallock, Madolin Fleet Barteau, and Ann Currie-Bell; (second row) Russel L. Davidson, Harry H. Reeve, Alvah B. Goldsmith, Israel P. Terry, Lewis A. Blodgett, and William J. Lindsay.

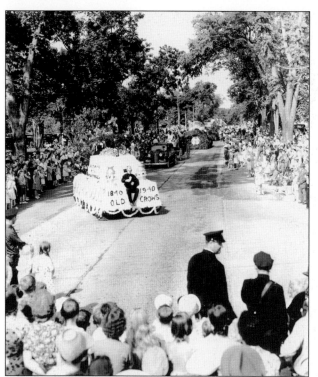

THE TERCENTENARY PARADE, 1940. Southold celebrated its 300th anniversary in 1940, and to mark that achievement, the town held a series of parades, exhibitions, and other social events. Here, the public watches excitedly as parade floats move down Main Road through the village.

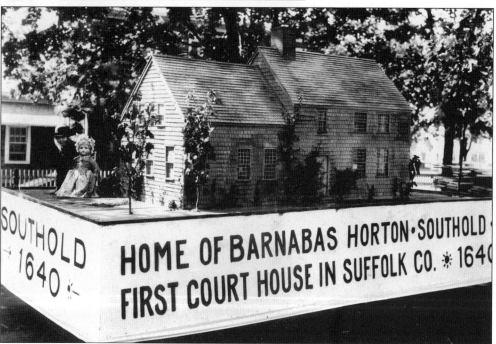

THE HORTON HOUSE FLOAT, 1940. The Horton House was one of the oldest structures in town when it was demolished in the late 19th century. To honor its memory, a float was built for the tercentenary parade in 1940. It is shown here decked out with a pair of dolls in period-style clothing.

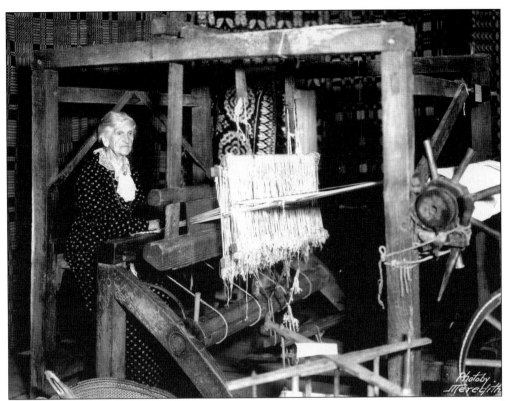

AUNT JERUSHA AT HER LOOM, 1940. The tercentenary celebration included all sorts of exhibits and demonstrations of old-world crafts and activities. Here, Jerusha Penny Overton Carpenter (1841–1940) works the loom that was built for her grandmother, Roxanna Miller Bennet (1786–1869).

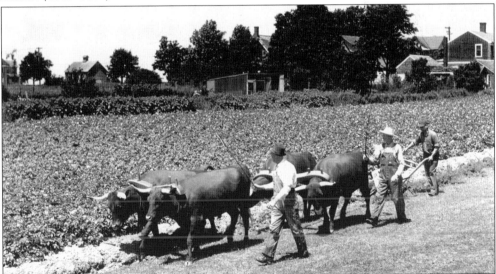

THE OXEN, 1940. In 1940, the town of Southold held a group of large events celebrating the 300 years since it was founded. Pictured are the tercentenary oxen performing a plowing demonstration held during the celebrations.

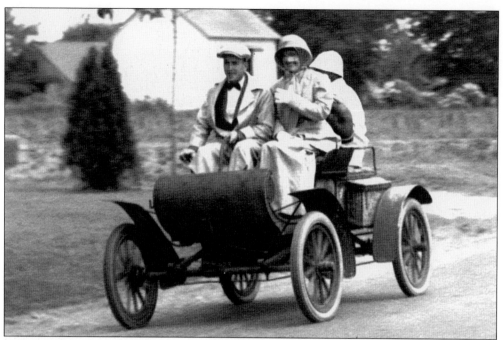

THE OLDSMOBILE'S RETURN, 1940. The infamous Howell Oldsmobile, the first automobile on Long Island's East End, was run one more time at the tercentenary celebration in 1940. Today, the car is housed at the Suffolk County Historical Society.

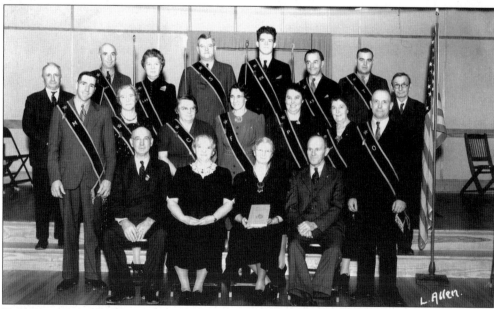

THE SOUTHOLD GRANGE, 1941. The Grange represented the interest of local farmers and served as a place of discussion. Among those pictured are Ethel Cosden, William Cosden, Ray Terry Sr., Ruth Tuthill Bergen, Susi Dickerson Goldsmith, Lisabeth Vail Dickerson, Elnora Hammond Boisseau, Roland Horton, John N. Lehr, Mahlon Dickerson, Isabel Benatre, Harold Tuthill, Teunis Bergen, Leander Glover Jr., Paul Benatre, and Ezra Beebe.

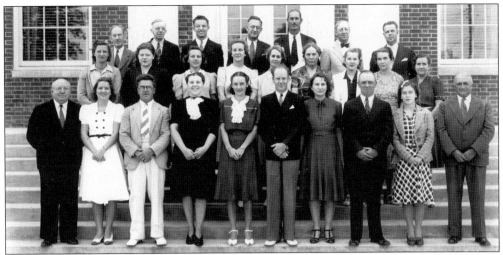

The Southold Town Choral Society, c. 1950. The choral society formed in 1936 and later joined with the Shelter Island Choral Society, creating the present North Fork Chorale in 1969. From left to right are the following: (first row) Nelson Moore, Jean Le Valley, Bob Taylor, Helen Linton, Karen Eckert, Harold Niver, Dorothy Lehr, Roland Horton, Jean Horton, and John Lehr; (second row) Edith Mills, Betty Ann Hagerman, Marian Dickerson, Mildred Newbold, Helen Palmer, Edith Prince, Elaine Niver, Helen Case, and Miriam Boisseau; (third row) Carl Le Valley, two unidentified people, Rev. Hoyt Palmer, two unidentified people, and Earle Linton.

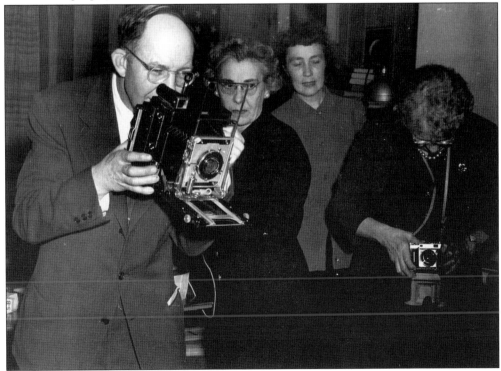

At the Camera Club, c. 1950. Participants in the club adjust their cameras. Those pictured From left to right are Fred Dart, Helen Thompson, Alice Dart, and an unidentified woman.

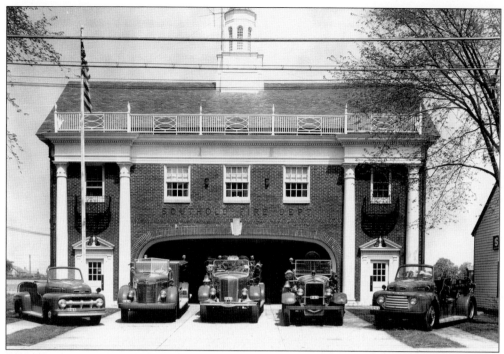

THE NEW FIREHOUSE, 1953. Built to replace the old Protection Engine Company building, on Beckwith Avenue, the new firehouse was completed in 1937. The building still serves as the headquarters of the Southold Fire Department, although it has been expanded several times since the 1930s. On the far right is a bit of the now lost Sinclair Service Station.

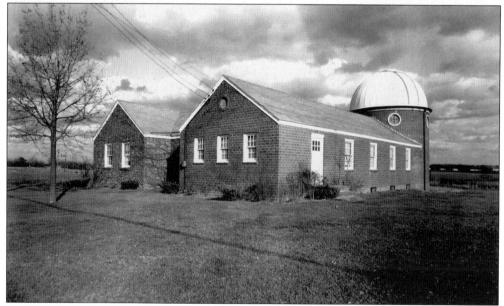

THE CUSTER INSTITUTE, 1956. A center for the amateur astronomer, the Custer Institute was founded by Charles W. Elmer, cofounder of the Perkin-Elmer Optical Company. The institute takes its name from Elmer's wife, May Custer Elmer, who was a grandniece of Gen. George Armstrong Custer. The building shown here was dedicated and opened to the public in 1940.

Four

HOMES

THE COL. JOHN YOUNGS HOUSE, C. 1900. The built environment is perhaps one of the only visible reminders of what has occurred in a community. The buildings that sit upon the land and that dot the streetscapes of Southold are what each succeeding generation remembers. Individual residences, whether still standing or lost, have become reminders of the people, places, events, and businesses that once represented Southold to the rest of the world. Nearly every type and style of residence known is represented in Southold, and nearly every type of construction can also be seen. From the earliest to the most modern, Southold is rich in architectural history. Located on the east side of Youngs Avenue, the Col. John Youngs House sits upon the colonel's original home lot, laid out in 1656. The house, altered and expanded many times during its history, shows indications that it was likely built elsewhere and moved to this site. Col. John Youngs (1623–1698) was the son of Rev. John Youngs (1598–1672), one of Southold's first settlers and its first minister. Colonel Youngs served as a member of King William III's Council of the Province of New York. Later owners included members of the Prince, Peters, Downs, and Rutzler families. The house has often been referred to as the oldest house in Southold village.

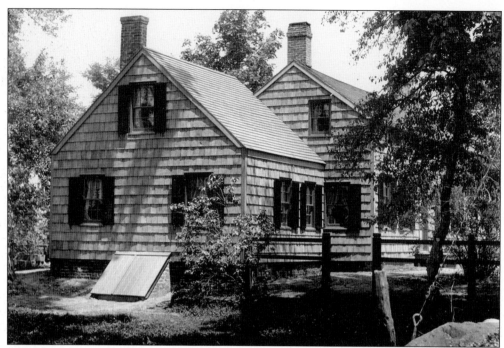

THE JEREMIAH VAIL HOUSE, C. 1940. Jeremiah Vail (d. 1687) was one of the earliest settlers of Southold, arriving here in 1659. Portions of this house are said to date from as early as 1656. The building originally stood on property near Tuckers Lane but was later moved eastward to a new site. In 1940, the house was carefully restored by Robert Lang.

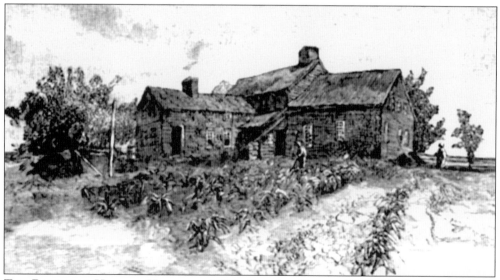

THE BARNABAS HORTON HOUSE, C. 1878. Barnabas Horton (1600–1680) was one of the early settlers of Southold and served for many years as a local magistrate. His house, built in 1659, was located on the site of his home lot, on the corner of Hortons Lane and Main Road. The house was one of the earliest in existence when the majority of it was torn down in 1878; only the rear kitchen wing was saved and moved to a new site on Bayview Road.

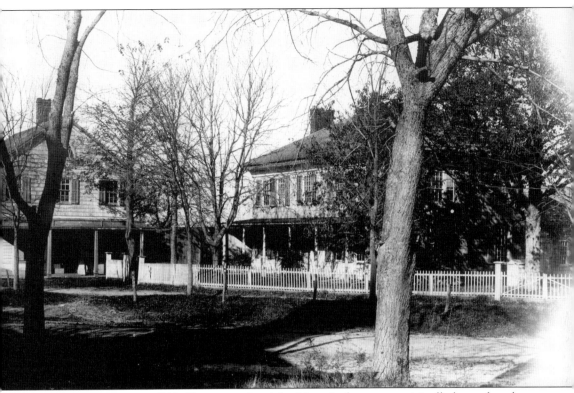

HUNTTINGHURST, C. 1870. Shown on the right, Hunttinghurst was originally located at the corner of Tuckers Lane and Main Road. It is said to incorporate portions of the house that was built by John Budd Sr. or Jr. in the 1660s. The house had many purposes during its history. From the late 17th through the mid-18th century, it was run as an inn by the Braddick, Moore, and Cochran families. Eventually acquired by the Huntting family, who gave it its name, the house served as the second home to the Southold Savings Bank from 1861 to 1891, and as home to the Lyceum Library. In 1908, the building was moved by Daniel H. Horton farther down Tuckers Lane, where it remains today.

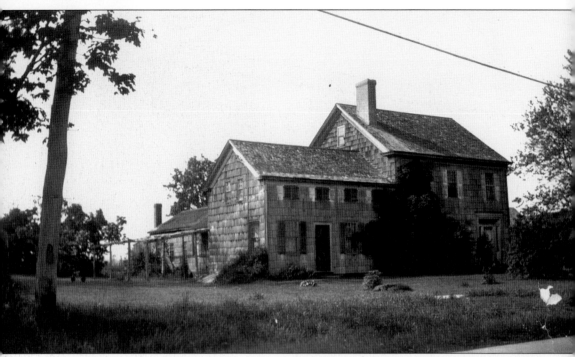

THE OLD CASTLE, C. 1930. Constructed *c.* 1724, the Old Castle formed the centerpiece of the Hutchinson family holdings, which were quite considerable, including extensive tracts of land at South Harbor, Indian Neck, and into the Corchaug Division. The house may incorporate a portion of another home built for Col. Samuel Hutchinson (1673–1737) early in the 17th century. The Old Castle was greatly enlarged by son Elijah Hutchinson (1698–1754) in the early 1750s. It later passed into the hands of the Landon and then the Horton families. By the mid-20th century, the home was owned by Mrs. Philip H. Horton.

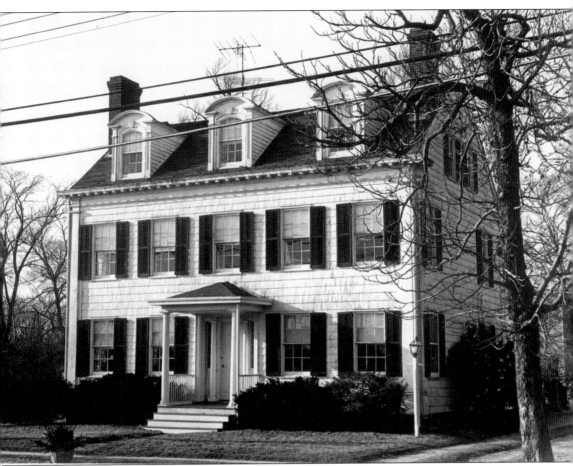

THE ROBERT HEMPSTEAD (HARTRANFT) HOUSE, C. 1972. Built for town clerk and justice Robert Hempstead (1703–1779), the house sits on the home lot of early settler Thomas Cooper. Later, justice of the peace Ezra C. Terry (1791–1849) bought the home and had local builder William D. Cochran enlarge it for him. Col. John Wickham (1810–1880) owned and enlarged the home further c. 1855. At the end of the 19th century, Dr. Joseph M. Hartranft (1857–1932) bought the house and had his medical practice in it. The Hartranft family lived here until the late 20th century, when a local developer acquired the property and demolished the house.

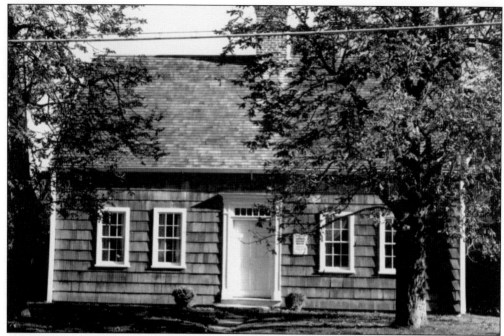

THE THOMAS MOORE HOUSE, 1972. Never lived in or owned by Thomas Moore Jr. (1616–1691), the house was likely built for Samuel Landon (1699–1782) in the third quarter of the 18th century. Its name comes from the site, the original home lot of Thomas Moore. The house was occupied by private owners until 1970, when the Kapp family sold it to the Southold Historical Society. It is a typical New England Cape in style, one of several in Southold dating from the 18th century.

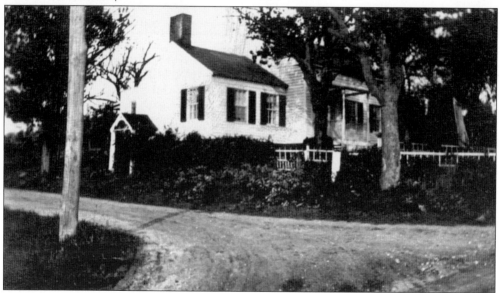

THE WILLIAM CASE HOUSE, C. 1910. This home, located on Bayview Road, is said to have had pre-Revolutionary origins and, by 1790, was occupied by William Case. In the late 1840s, Henry M. Beebe, husband of Mary Wells Beebe, was the owner. By 1960, the house had become the residence of Nicholas Cerigliaro.

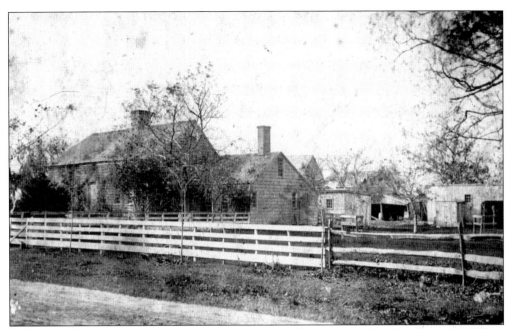

THE OLD PLACE (NORTHSIDE), C. 1880. The ancestral home of the Case family, the Old Place (also called Northside) was located on the North Road in Peconic. It was the Cases' home until 1887, when the family moved into a remodeled home on Peconic Lane. The Old Place was leased out to be worked by other local farmers.

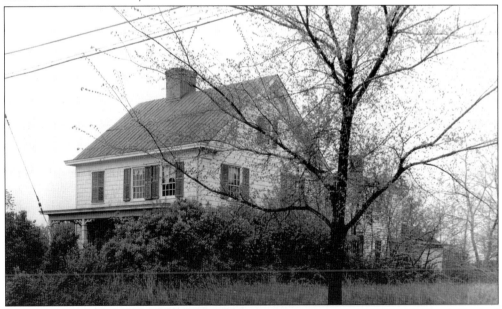

THE REVEREND JONATHAN HUNTTING HOUSE, 1940. The large house with Greek-Revival detailing was built by the Reverend Jonathan Huntting (1778–1850). Huntting served as the minister of the Presbyterian church from 1807 until 1828, when he was asked to leave his post by church trustees. Later, the building served as the first home of the Southold Savings Bank (1858–1861). Located on Main Road at the west end of the village, the house was torn down c. 1965.

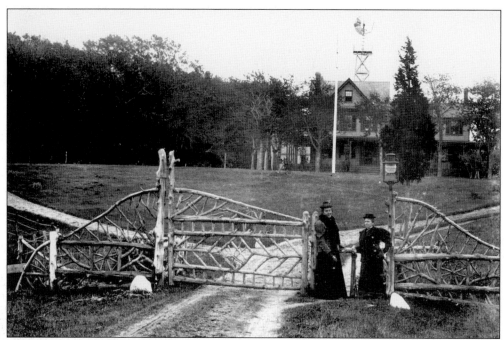

THE GEORGE HARPER RESIDENCE, C. 1890. George Harper (c. 1838–1910) was born in England and later emigrated to America. In Brooklyn, he became a well-known hatter and furrier, residing on Henry Street. Harper purchased 30 acres on Calves Neck in 1889, and he and his family lived in an elegant home there, portions of which dated back to 1815, when it was built by the Lester family. The house was later the residence of state supreme court judge L. Barron Hill (1896–1985) and his wife, Adelaide Harper Hill (1902–1996), daughter of George Harper's son, George S. Harper (1876–1911).

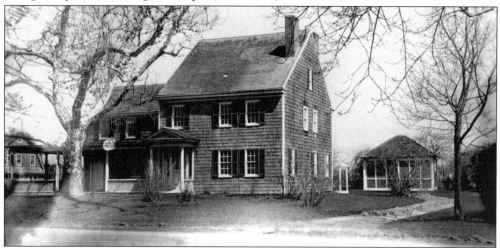

THE AUSTIN HORTON HOUSE, C. 1940. Of typical side-hall plan, the Austin Horton House was located on Bayview Road on Great Hog Neck. Austin Horton (1805–1893) was a farmer who, like so many of his predecessors, lived a very long life for the period. In fact, Southold is noted for the longevity of those who lived here. In 1901, resident N. H. Cleveland reported that between 1892 and 1900 more than 50 people had died in the town who had achieved an age ranging between 80 years and 97 years.

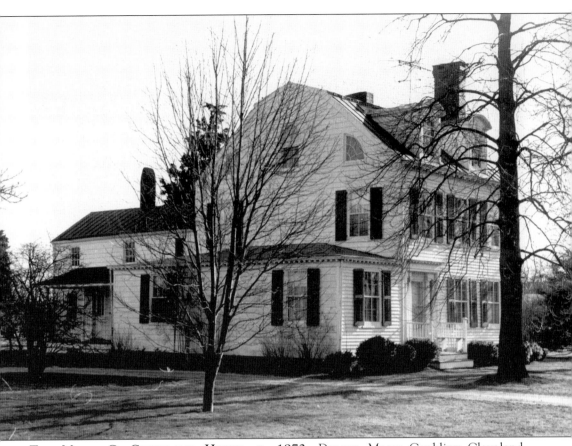

THE MOSES C. CLEVELAND HOUSE, C. 1972. Deacon Moses Conkling Cleveland (1795–1883) was the son of Moses (1770–1848) and Parnel Conkling Cleveland (1772–1857). The house was constructed east of the Universalist church *c.* 1835, probably to the designs of local architect and builder William Cochran. The Greek Revival detailing, including Doric columns, tracery sidelights, corner-board pilasters, and arch-top dormers, make for an elegant building. Cleveland was a prominent member of the community and served many years as a deacon at the Presbyterian church. The house passed to his son N. Hubbard Cleveland and was eventually acquired by the Charnews family.

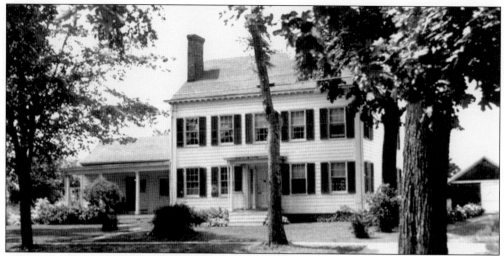

THE CAPT. BENJAMIN WELLS HOUSE, C. 1920. Built in 1836 in the Greek Revival style, this impressive home was the residence of Capt. Benjamin Wells (1793–1879). Benjamin Wells was born in Southold and went to Sag Harbor as a young man to learn the trade of a cabinetmaker. After a few years, he decided it was not the profession for him and he went back to his first love, sailing boats. He captained a number of vessels, all of which he owned, transporting passengers and goods between New York City and Southold. His home was later owned by his son Oscar Lewis Wells (1859–1936). During the latter part of the 20th century, a number of different retail clothing stores and offices occupied the building.

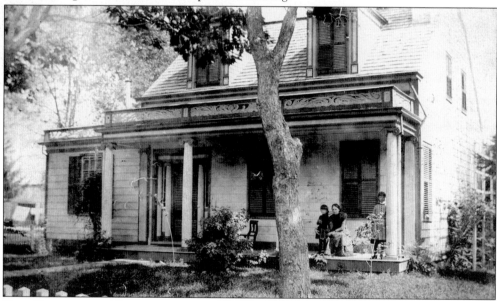

THE RENSSELAER HORTON HOUSE, C. 1885. Built *c.* 1838 by Rensselaer Horton (1793–1885), the house was originally located on the corner of Main Road and Youngs Avenue. By the late 1800s, a number of owners had passed through the house, including Joseph Goldsmith (1832–1905) and J. Wickham Case (1806–1896). In the early 1900s Jerusha Horton (1834–1925) was living here. In the 1920s, Judge L. Barron Hill (1896–1985) briefly made it his residence, followed by Margaret Harper (b. 1872). By that time, the house had been moved from its original location and relocated farther down Youngs Avenue.

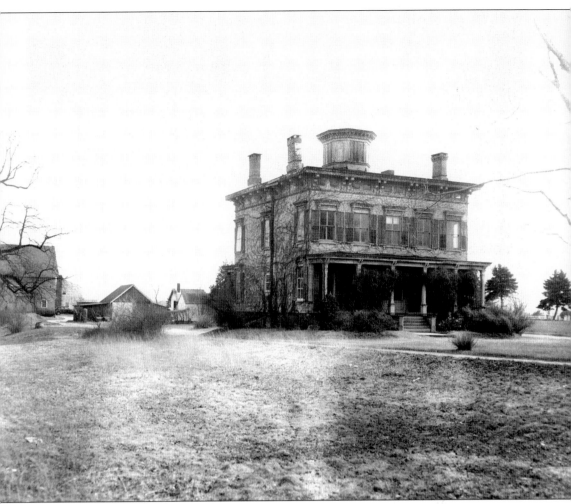

THE ISRAEL PECK HOUSE, OAKLAWN, 1966. Israel Peck (1814–1881) was born in Connecticut. In 1840, he married Nancy Halsey Glover (1818–1893) in New York City and moved to Southold in the early 1850s. A prominent farmer, he constructed a massive Italianate residence on the south side of Main Road next to the Presbyterian church between 1852 and 1856. The house displayed Peck's wealth and position to the community and became the home of his wife and six daughters, all of whom married into other prosperous families. His Oaklawn Track, located at the rear of the property, featured horse races that were quite popular during the 19th century. After his death the house was sold to George Wells and then to Samuel S. Dickerson c. 1885. Charles Grigonis, the last owner to live in the house, sold the property to the Security National Bank, which demolished the house in April 1966.

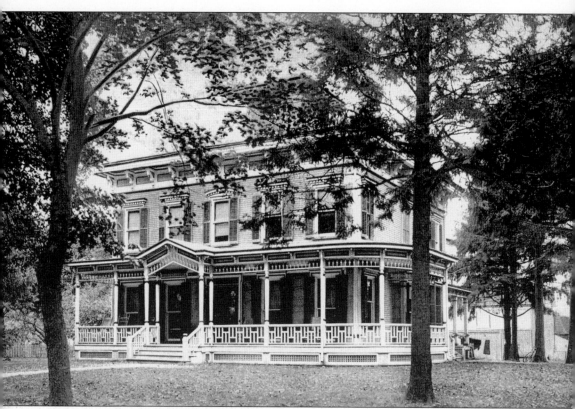

THE ALBERTSON HOUSE, C. 1915. Built on the southeast corner of Main Road and Youngs Avenue, the Albertson House was one of the largest and most impressive residences on Main Street. Probably constructed for G. P. Horton *c.* 1857, it is most often associated with local businessman William Conklin Albertson (1850–1899) and his wife, Jennie Wells Albertson (1855–1897). Albertson ran a local farm-produce shipping and supplying company that bore his name. Following Albertson's death from cancer in 1899, the property was operated by W. F. Mitchell as a boardinghouse called the Albertson House. Still later, it served as the town clerk's office. Between 1955 and 1956, it was demolished to make way for the new Bohack Supermarket, which later became the Southold IGA.

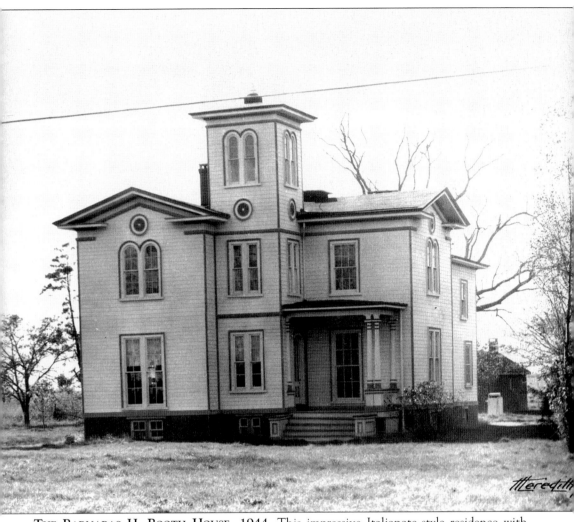

THE BARNABAS H. BOOTH HOUSE, 1944. This impressive Italianate-style residence with tower was designed and built on the bend on Main Road by Barnabas H. Booth (1812–1900) in 1861. Barnabas Booth grew up in Southold and left at an early age to begin his career as a carpenter and builder of houses in Brooklyn. In 1856, he returned to Southold and acquired the property on the corner of Tuckers Lane, where eventually built the house and farm for his remaining years. By 1903, the property been acquired by local farmer Oliver A. Mayo (b. 1840). The house was owned by Alfred Simon in the early 1940s, when it was sold to become the home of the Southold's American Legion Post No. 803.

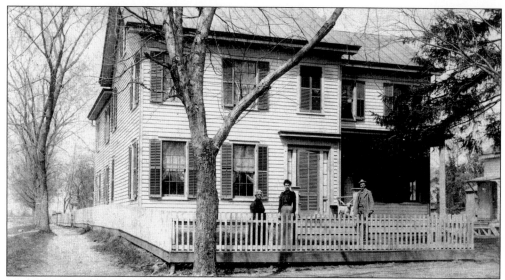

THE BECKWITH-STEVENS HOUSE, C. 1903. Located on the corner of Beckwith Avenue and Main Road, the Beckwith-Stevens House was built in 1867 for Capt. Sherburne Beckwith (1822–1896) by local carpenter William H. Corwin (b. 1831). Originally from Salem, Connecticut, Sherburne Beckwith operated a ship chandlery in Greenport after arriving here. His daughter, Mary, eventually married noted doctor J. M. Hartranft (1857–1932). Pictured are, from left to right, Nancy Beckwith (b. 1830), Esther Gildersleeve Dickerson, and Albert Tuthill Dickerson. The Beckwith-Stevens House was later turned into offices.

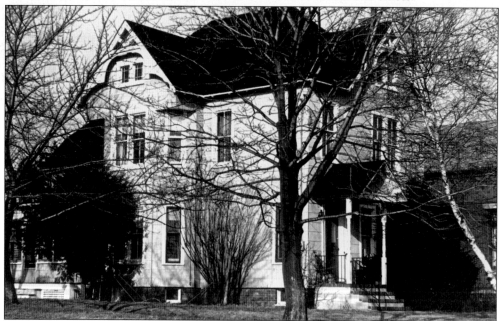

THE LEWIS-COCHRAN HOUSE, C. 1972. Built sometime after 1870, this house was the residence of Carrie J. Lewis (b. 1860), who operated the building as a boardinghouse. It was owned by the Lewis family until it was acquired by William A. Cochran in 1919. A wonderfully detailed Victorian structure, the house was acquired by developers and demolished in October 1989 to make way for the Feather Hill retail stores.

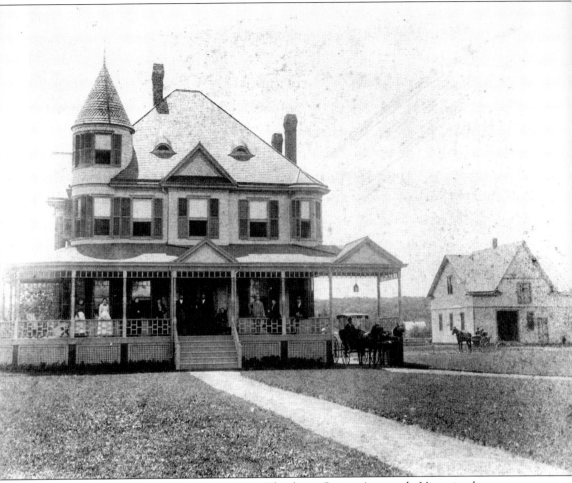

THE WILLIAM H. WELLS HOUSE, C. 1890. This large Queen Ann–style Victorian home was built on the southwest corner of Main Road and Maple Lane in 1892 for William Hull Wells. William H. Wells (1859–1904) was the son of Joseph A. (b. 1836) and Helena Goldsmith Wells (d. 1859). Following his death, the house was sold in 1904 to Sinclair Smith (c. 1857–1938), a Brooklyn resident with a penchant for yacht and horse racing. Smith's ship, the *Spray*, was a strong competitor in the races held regularly off the coast of Shelter Island. Smith was the president of his family's paint-manufacturing and importing company, located in Long Island City. The house was damaged during the 1938 hurricane and was demolished by Smith not long after.

THE INTERIOR OF THE WILLIAM WELLS HOUSE, C. 1890. In this image, the elegant Victorian furnishings of the Wells house can be seen. The heavily carved furniture, detailed textiles, and patterned wallpaper were all common interior decorations of the period.

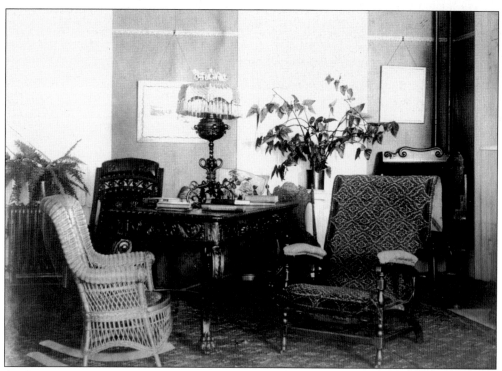

AN INTERIOR VIEW OF THE BLISS HOME, C. 1910. The Bliss home, often used only during the summers, is decorated very simply. Palms and ferns, popular during the era, are juxtaposed with the heavily carved furniture typically found in late-Victorian and Edwardian residences.

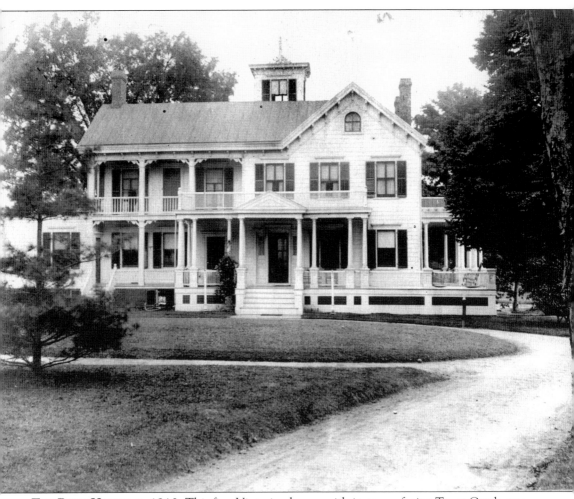

The Bliss House, c. 1910. This fine Victorian home, with its tower facing Town Creek, was built probably for Frank L. Judd, manager of the Southold Hotel, in the early 1870s, although it may have included part of a house owned by J. Wickham Case. The house was located at the end of Maple Lane, and was later sold to the Joost family, and then to John A. (1864–1906) and Flora B. (1866–1953) Bliss. The Bliss family occupied the house for several years, sometimes renting it out to friends such as the Cosden family. The house was later reacquired by members of the Joost family, whose descendants currently own the home, now lacking its fine porches and tower.

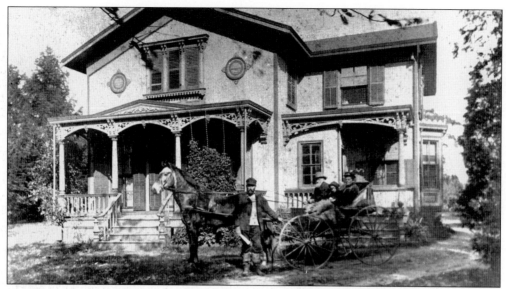

THE LEWIS R. CASE HOUSE, C. 1900. Remodeled in 1887, the house became the residence of the Case family after the Case ancestral home, the Old Place, had been let out to other farmers. A magnificent Victorian residence, it was home to several generations of the Case family. From left to right are Dr. Josiah Case, Lewis R. Case, Rosalind Case Newell, and Katherine Williams Case. Located on Peconic Lane north of the railroad, the house was one of the first in Peconic to have a bathroom (1887).

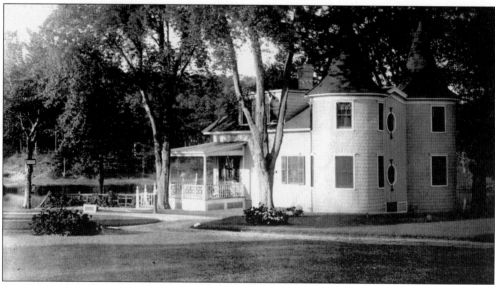

THE WILLIAM JOOST HOUSE, ROSEMARY, C. 1910. This was one of the more unusual houses in Southold, with its pinnacle-roofed towers. It was the summer residence of William Joost and his wife. Prominent residents of Brooklyn, the Joosts first came to Southold when they purchased the S. B. Terry property in 1895. In 1899, they sold most of that property to the Bliss family, keeping a small portion with a cottage for themselves. The cottage was greatly enlarged and renovated in 1908, including the addition of two towers on the north side of the building. Originally located on Maple Lane, the house was later moved by barge to a new location in Southold, where it remains today.

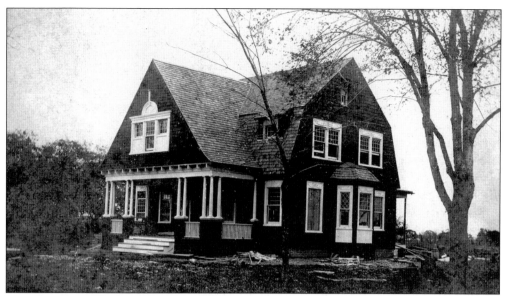

THE HALLOCK-CURRIE-BELL HOUSE, C. 1900. Shown with the finish work still going on, this house was built for Joseph N. Hallock and his wife, Ella Boldry Hallock. The home was completed in 1900 and served as the Hallock residence until the home was inherited by their daughter Ann Hallock Currie-Bell (1897–1964), wife of local painter Thomas Currie-Bell. It continued to serve as the daughter's residence alone until 1960, when she helped found the Southold Historical Society and became its first president. At that time, the historical society was partially housed in her home. In 1964, she died, leaving her home to become the first museum and headquarters of the Southold Historical Society. Today, the building is open to the public.

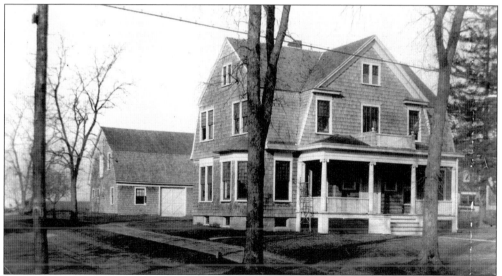

THE FREDERICK C. WILLIAMS HOUSE, C. 1910. A large Arts and Crafts–period home, the Williams house was built on the west side of Main Road, near the bend. It was built for Frederick Charles Williams (1867–1908) and his wife, Elsie Elmer Williams (1867–1934). Williams, a local businessman, operated a grocery store in Southold. The large barn–carriage house and the Williams home still exist today.

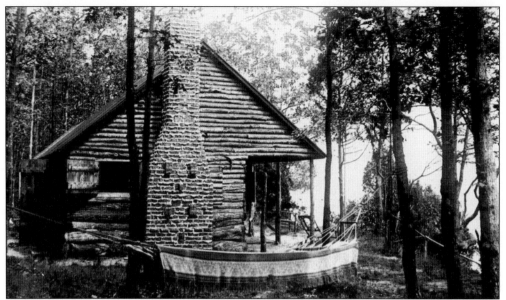

CABIN PARADISE, C. 1905. Cabin Paradise was established by the Hallock family as a summer house, the first built on Paradise Point. Over the next 25 years, many people stayed in the little log cabin, from brides to family guests.

THE ALBERT A. FOLK HOUSE, C. 1915. This large brick home was built *c.* 1910, after the marriage of Albert Albertson Folk (1842–1924) and Lucy Hallock. The house became the couple's home. It was located on Maple Lane, just south of the residence of Lucy's brother, Joseph N. Hallock. During its heyday, the Folk home was known for the magnificent garden which occupied the rear yard of the house.

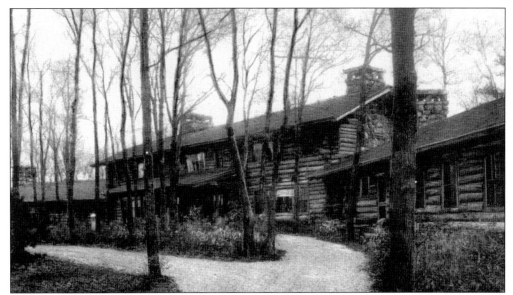

THE WILLIAMS ESTATE, THE LOG CABIN, C. 1915. Alexander S. Williams (1866–1932) had been involved in the lumber industry since 1882, and so it was only appropriate that when he decided to build himself a summer residence, it was to be built completely out of wood. The Log Cabin was the result of his work. Located on Jockey Creek and Southold Bay, the house was designed as a large rustic compound, with log walls, stone chimneys, and lovely views of the water. Williams eventually became the chairman of the board of the Astoria Mahogany Company and later dabbled in trading stocks. In recent years, the house has been greatly enlarged and renovated.

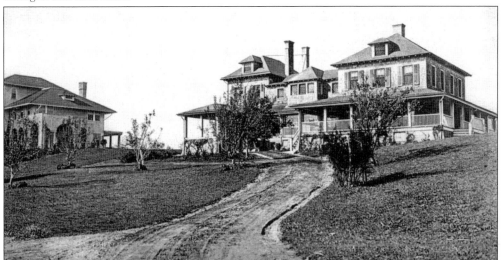

THE MARSHALL ESTATE, BREEZY BLUFF, C. 1915. Dr. Joseph H. Marshall (1854–1932) was the first of a group of men including Edward D. Cahoon and Alfred H. Cosden to build large estates on the bluffs overlooking Long Island Sound. All were business partners who had met while building the Riker-Hegeman Drug Company into one of the largest in New York City. The Marshall house, on the right, was was the first of those to be built. A conglomeration of wings finished in the popular Shingle style completed the cozy summer residence for the family. Breezy Bluff was demolished *c.* 1932.

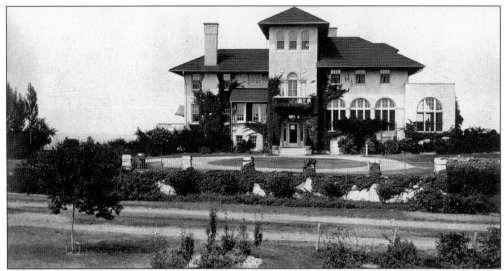

THE CAHOON ESTATE, OVER-THE-SOUND VILLA, C. 1915. Edward Daley Cahoon (1859–1920) was born and raised in Delaware and was the son of the owner of a profitable carriage-building enterprise. He became a pharmacist and eventually took over the Riker Drug Company with his friend Dr. Joseph H. Marshall. With Alfred H. Cosden, Cahoon and Marshall built the company into one of the largest drug companies in New York City. He joined with his compatriots in building magnificent summer houses in Southold. The Cahoon house, designed by James L. Burley, was a Mediterranean villa with Arts and Crafts–style interiors. The property included several outbuildings and a large water tower. The house was inherited by Cahoon's daughter Edna Cahoon Booth (1899–1964), who had the house torn down in the 1930s.

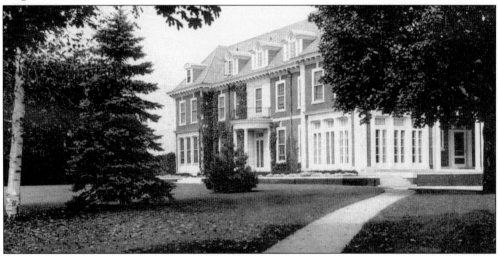

THE ALFRED H. COSDEN MANSION, EASTWARD, C. 1930. Built on the bluffs overlooking Long Island Sound, Eastward was completed in 1916 for Alfred Houston Cosden (1873–1962) to the designs of noted architect James L. Burley. Cosden was born in Delaware and became a noted businessman, serving as president of the Riker-Hegeman Drug Company in New York City. In his spare time, he was devoted to trotting and racing horses, including Vito, who won the Belmont Stakes in 1928. His magnificent Georgian-style home was demolished between 1940 and 1941, although many of the outbuildings, including the garage-stable complex, superintendent's cottage, and chauffeur's cottage, survive to this day.

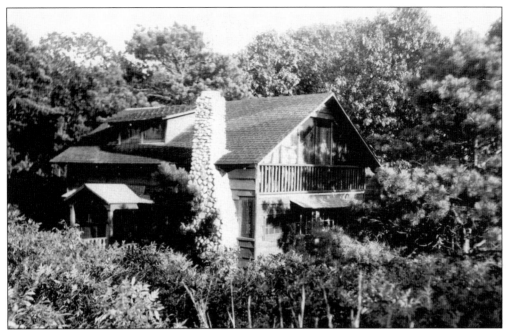

THE BANDBOX, C. 1925. Built on some of the remaining lands owned by the Hallock family at Paradise Point, the Bandbox was the last building project of Ella B. Hallock. The little getaway was occupied by Ann and Thomas Currie-Bell on their wedding night, in 1929. Privately owned today, it still stands at Paradise Point.

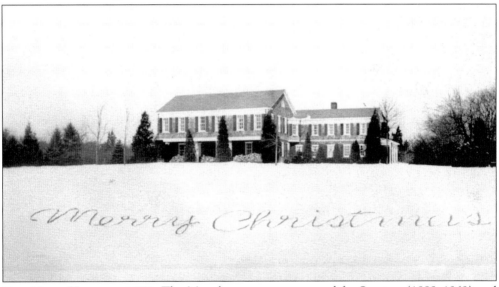

THE MOTT HOME, C. 1930. The Mott home was constructed for Stanton (1888–1969) and Gladys Matthews Mott by local carpenter Henry Goldsmith, beginning in January 1925. Shown here at Christmastime, the house was located on South Harbor Road in Peconic and was designed in the Colonial style. The materials used to build the house were supplied by Sears and Roebuck and shipped via train to Peconic. Mott, a partner in a publishing firm, lived in Brooklyn when not summering in Peconic. The house was used in retirement by the Motts until it was sold in 1966 to be developed by Henry Smith.

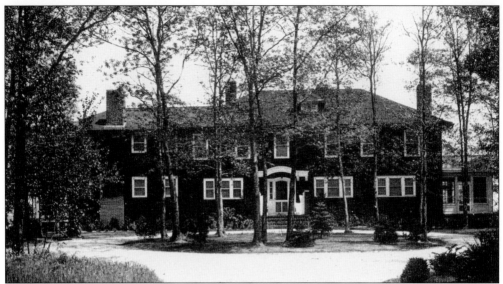

THE J. S. JENKINS HOUSE, C. 1930. John S. Jenkins (b. 1870) was a successful attorney who was born, raised, and employed in Brooklyn. He and his wife, Caroline Jenkins (b. 1874) built this beautiful home on Paradise Point as a summer residence. After her husband's death, Caroline Jenkins continued to use the home through the 1950s. The house was later occupied by the Jenkins's daughter, Constance "Leah" Proctor, and later, by the Ward family.

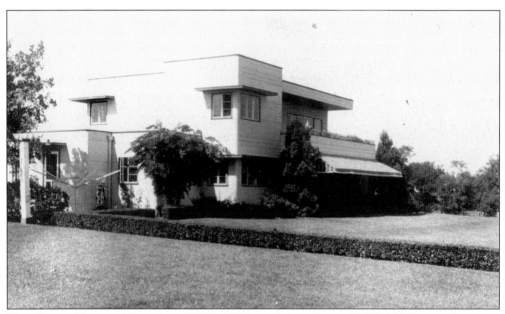

THE ROON HOUSE, 1943. Leo (1892–1983) and Ann Roon (1895–1986) were longtime summer residents of Southold. When they first arrived, they acquired this Art Moderne–style home located on Town Harbor Lane. They lived here for many years before acquiring Lighthouse Farm from Allen Tobey in 1943. They occupied the estate until 1955, when they sold their Southold property and moved to California. Roon, a noted businessman and sculptor, developed several important innovations in the painting and finishing business. The house, although somewhat altered, still stands.

70

Five
FARMING

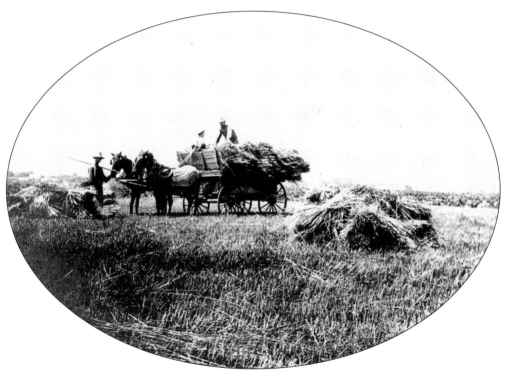

HAYING TIME, C. 1890. Southold's main industry has, for generations, been farming. Families grew grains and vegetables of all sorts and raised animals for sale and slaughter. Dairies were not uncommon. Crops such as cauliflower became king for a long time, but nothing proved more long-lasting than potatoes. As with most of Long Island, potatoes dominated the agricultural industry of Southold from the late 19th century through the mid-20th century. Today, many of the largest farms no longer grow potatoes but raise grapes for a wine industry that has become one of the most important on the East Coast. Here, workers begin gathering hay in preparation for wintertime. The hay was bundled, loaded onto a wagon, and taken to a barn, where it was unloaded into the hayloft for storage over the winter. A barn was needed not only to store hay but also to house animals.

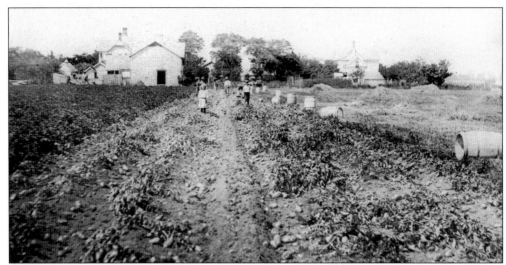

AT THE HUMMEL FARM, C. 1900. Frank Hummel and his family lived, appropriately, on Hummel Avenue north of the railroad in Southold. Here, workers harvest potatoes behind one of the Hummel residences. Once picked, the potatoes were placed in barrels, shown alongside the row, and taken to the train depot for shipment.

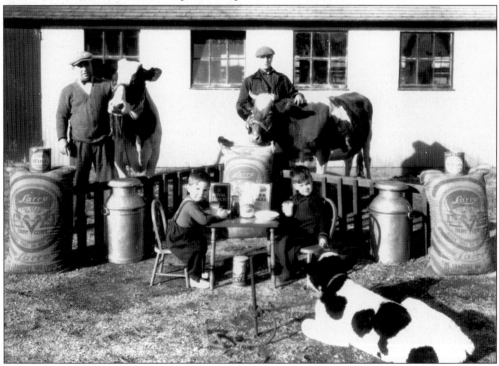

AT THE CORAZZINI FARM, C. 1927. Members of the Corazzini family pose with part of their dairy herd for a milk advertisement. The two boys seated at the table are likely Anthony (b. 1924) and Clarence (b. 1921) Corazzini, the sons of Thomas (b. 1895) and Regina (b. 1897) Corazzini. Thomas Corazzini arrived in America in 1899 and eventually moved to Southold, living on Cassidy Lane (named for the Cassidy Farm that once existed off Albertson Lane) on the east side of Hashamomack Pond.

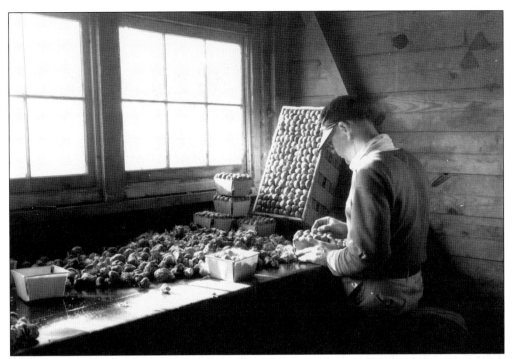

GRADING BRUSSELS SPROUTS, C. 1930. One of the more painstaking and time-consuming activities is shown here: the grading of Brussels sprouts. Sprouts, along with cauliflower, were a big business on eastern Long Island at one time.

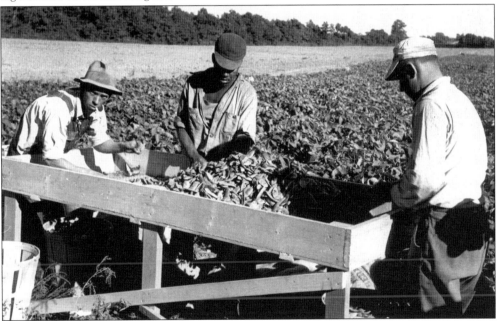

SORTING BEANS, C. 1930. Two migrant workers assist in sorting beans on a farm in Southold. Each year, hundreds of African Americans arrived on Long Island to work at local farms for the season. The workers lived in camps scattered across Long Island, staying for months at a time before returning to the South for the winter.

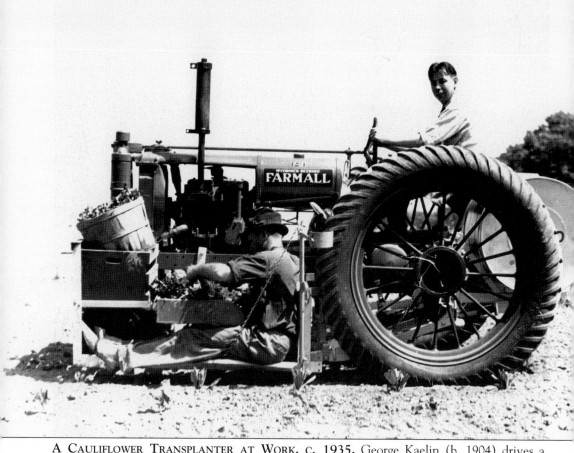

A Cauliflower Transplanter at Work, c. 1935. George Kaelin (b. 1904) drives a McCormick-Deering Farmall F-12 tractor with a cauliflower transplanter attachment. Seated in the transplanter is Bill Conway (b. 1907), who is taking young seedling cauliflower and hand-planting it in the field, where it will grow to full size. Two men, one on either side of the tractor, could plant two rows simultaneously. Cauliflower was a huge business on Long Island for decades and was represented locally by the Long Island Cauliflower Association.

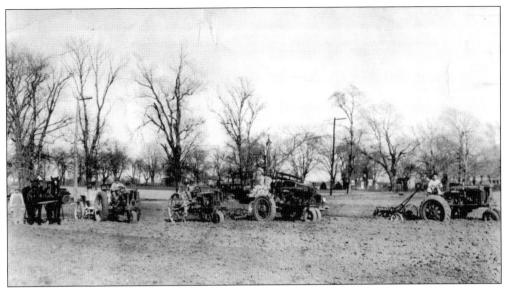

A FARMALL TRACTOR DISPLAY, 1938. See how much better the tractor is than the plow. From left to right are a horse-drawn plow, a McCormick-Deering Farmall F-12 tractor with potato planter, a Farmall F-12 with no implements, a Farmall Regular with disk harrow, and a Farmall F-30 with plow. This scene was probably shot at Oscar Case's place on the west side of Peconic Lane.

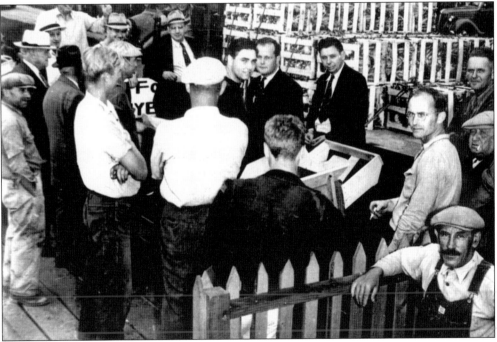

A CAULIFLOWER AUCTION, c. 1938. The auctioning of agricultural products was very common here and elsewhere. This auction is taking place at the Gagen, Carroll, and Edwards property, at the corner of Hummel and Boisseau Avenues. Among those pictured are Charlie Van Duzer, Russell Tabor, Frank Zaleski, George Kaelin, James Baker, Joe Booth, Felix Stankewicz, Al Papish, Dwight Corwin, and Burt Stepnoski.

SORTING POTATOES, 1956. Tony and Henry Krupski sort potatoes on South Harbor Lane in Southold. Frank Krupski (b. 1875) emigrated to the United States in 1908 and arrived in Pennsylvania, later coming to Southold. The Krupskis joined hundreds of other Polish and Lithuanian families who had already settled on the North Fork.

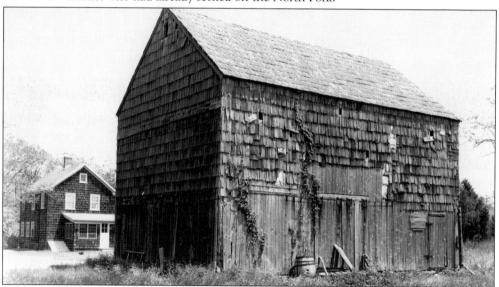

THE ANCIENT PINE NECK BARN, C. 1960. Originally located on Pine Neck Road, the barn is believed to date to *c.* 1750. It has had many owners, including the Corwin, Tuthill, Adams, and Breitstadt families. Lillian C. Breitstadt and her sister Edith B. Mailler presented the barn to the Southold Historical Society in 1961. The upper levels of the barn stored hay, and the lower areas housed animals. Barns such as this one, once numerous across Long Island, have all but vanished.

Six

BUSINESSES

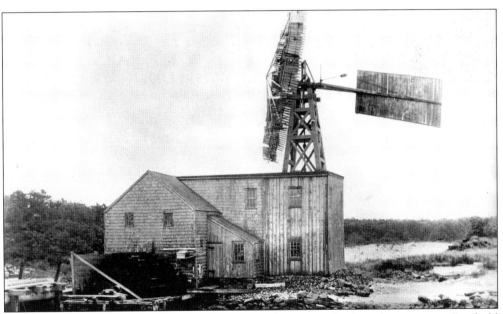

THE PECONIC MILL, C. 1890. Excluding farming, there were few large businesses in Southold before the late 19th century. Milling was the earliest large-scale industry, and a variety of partnerships established mills her during the 17th and 18th centuries. In the 19th century, many small to mid-size businesses were established—dry goods stores, a bank, hotels, brickworks, blacksmiths, and carriage builders. In the 20th century, stores appeared and disappeared, and large chains such as the Great Atlantic and Pacific Tea Company (A & P), Bohack, and the Independent Grocers Association (IGA) arrived. The Peconic Mill was authorized by the sale of stock in 1838 but was not completed until 1843. It stood on the west side of Goldsmith's Inlet just north of Peconic. It depended on the tidewater to operate: the water rushed into the inlet, where it was trapped by a lock and routed to the millrace. In the latter part of the 19th century, a large windmill was added to the mill so that at times when the tides could not power it, the wind could. The mill was in operation until November 27, 1898, when a great winter storm destroyed the windmill blades. After that the mill was abandoned, and it sat for many years, slowly falling to pieces.

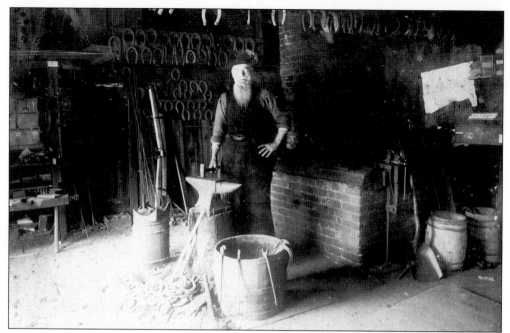

CLEVELAND'S BLACKSMITH SHOP, C. 1895. Henry Conklin Cleveland (*c.* 1825–1902) poses in his blacksmith shop amidst the varied tools of his business. He opened the Main Road shop in 1845, after completing his apprenticeship in Springfield, Massachusetts. For the next 30 years, he worked alone, serving the population of Southold. In 1876, he took on a partner, William H. Glover. Frank M. Gagen joined the firm in 1901, not long after Cleveland's retirement, and in 1921, he purchased the business. The shop was closed in 1941, almost 100 years after it was first founded.

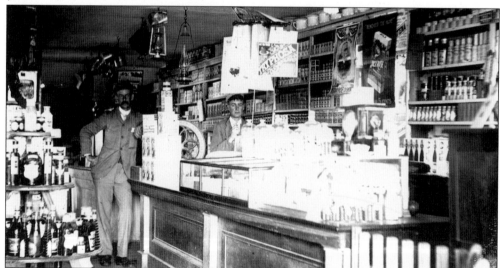

AN INTERIOR VIEW OF THE FRANK T. WELLS STORE, C. 1900. A store that offered all sorts of general merchandise, the Wells Store was located on the north side of Main Street just west of the Henry W. Prince Store and east of the Beckwith Home. Dating from the mid-19th century, or perhaps earlier, this building was first renovated for commercial purposes by Capt. Sherburne Beckwith. Today, the building is occupied by a real estate office.

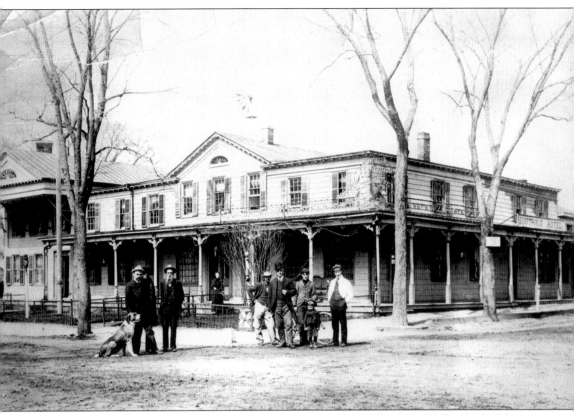

THE SOUTHOLD HOTEL, C. 1900. Constructed as a store for William H. Wells, the building served as a store from 1830 until sometime after 1858, when son Albert Wells took over. It was at this time that the shop expanded its operations to include a hotel. By 1873, Col. J. Wickham was the owner, and in 1875, Frank L. Judd took over the business. Under Judd's management, the hotel was greatly expanded and improved. The final owner was Theodore Hoinkis (1864–1929). In 1926, the hotel was dismantled, with many parts becoming houses elsewhere in town. From left to right are Theodore Hoinkis, Fred Prince, Clara Hoinkis (1865–1947) unidentified, Jeremiah Lucey, Joe Gomez, unidentified, and Dominick Perry.

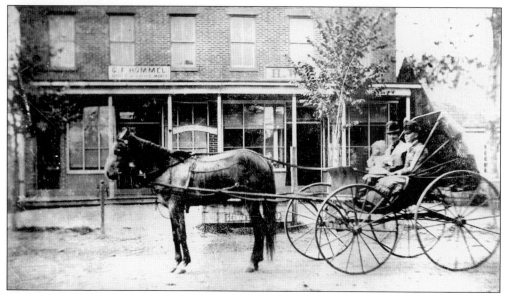

THE H. W. PRINCE BUILDING, C. 1891. The Prince Building was constructed by Henry W. Prince (1839–1925) in 1874. Prince occupied the eastern half of the building, and his friend and business partner, G. Frank Hommel (1840–1909), occupied the western half. The store had the first telephone exchange in Southold, in 1895, and was for a time the home of the post office. Prince leased out the basement of the building to an oyster bar. Today, the building is the headquarters of the Southold Historical Society. The Case family is in the carriage.

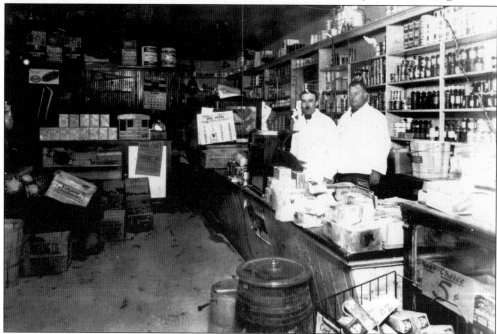

AN INTERIOR VIEW OF THE H. W. PRINCE BUILDING, C. 1920. The store on the western side is pictured when it was occupied by Grattan's Market. Christopher Grattan (b. 1887) stands on the right. Hanging on the mirrored counter in the background is a poster for an upcoming card party at Community (Belmont) Hall.

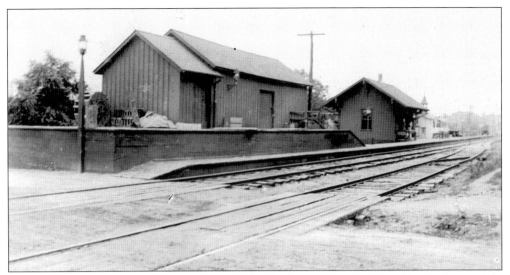

THE SOUTHOLD RAILROAD STATION, C. 1905. The Long Island Rail Road had its beginnings in the 1840s, but it was not until the 1870s that the resurrected company began to truly service the island. The Southold station, shown in the background beyond the original baggage house, was built in 1870 and was torn down in 1962, a time when many depots across Long Island were disappearing.

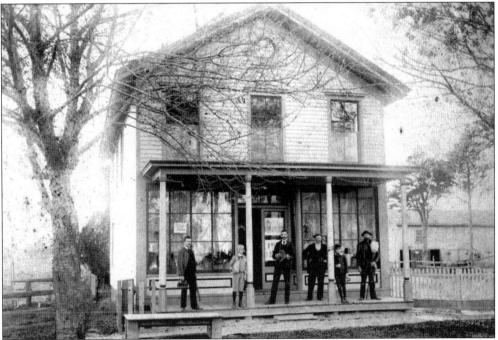

F. D. SMITH'S MILLINERY SHOP, C. 1885. Known across eastern Long Island for his exquisite hats, Frank Davis Smith (c. 1862–1942) actually began his career as a clerk in one of the Peconic village stores. Later, he traveled to New York City, where he learned the tailor's trade. He returned to Peconic and opened a tailors' shop but quickly became consumed by trimming hats. It is believed that during his long career he trimmed more than 20,000 hats and perhaps as many as 40,000.

THE W. C. ALBERTSON STORE, C. 1890. The William C. Albertson Store was located on the north side of Main Road in Southold, nearly opposite Mullen Motors and next door to Single's Carriage Shop, shown on the right. The store was the headquarters of the W. C. Albertson and Company, packers and shippers of Long Island produce.

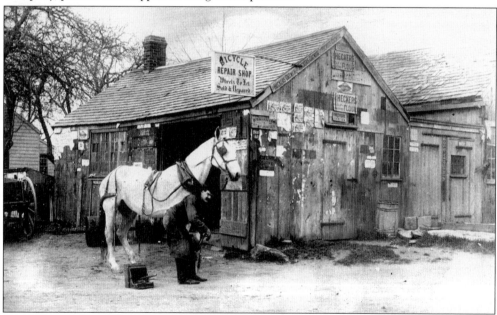

MORRELL'S BLACKSMITH SHOP, C. 1915–1920. Rufus T. Morrell (b. 1848) established his blacksmith business just south of Robert Jefferson's store on the corner of Peconic Lane and Main Road. Nearly every small village on the North Fork had one or more blacksmiths around to ensure that horses would be shoed regularly. As can be seen, Morrell liked to use his shop for advertising as well as for work.

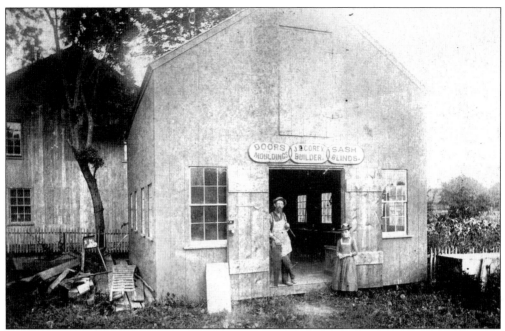

J. E. Corey Carpentry Shop, c. 1887. J. Edward Corey (1851–1928) stands in the doorway of his shop with his daughter, Bertha (b. 1877). He married Betsey A. MacKenzie (1853–1934) in 1876. A successful local carpenter and builder, Corey constructed many buildings in Southold, including the J. N. Hallock House, on Main Road. His shop was on on Railroad (Youngs) Avenue.

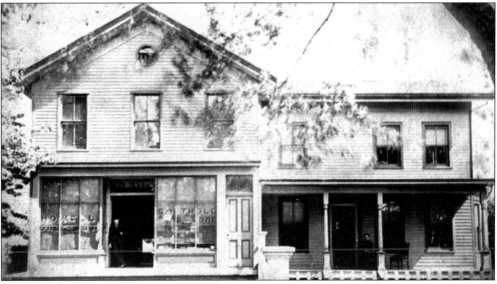

H. G. Howell's Drug Store, c. 1890. Henry G. Howell (b. 1841), the proprietor, stands in the doorway of Howell's Drug Store, located on Main Road. A pharmacy existed on this site as early as 1873, although the building shown here was constructed in 1882. Howell's was the place to acquire all the popular patent medicines of the late 19th century. Later, the building was occupied by Millard W. Golder's Drug Store (1906–1922). Today, it is home to Rothman's Department Store.

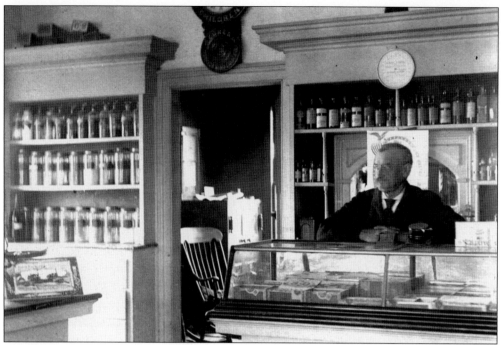

AN INTERIOR VIEW OF H. G. HOWELL'S DRUG STORE, C. 1890. Henry G. Howell stands at the counter in his immaculate store. Bottles of remedies line the shelves, and Howell's large safe can be seen through the doorway.

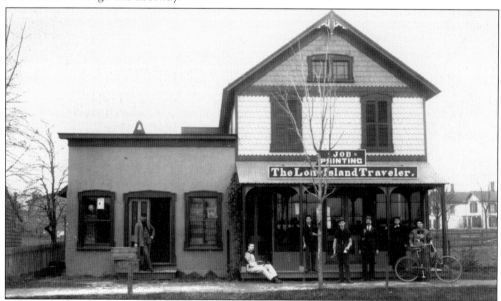

THE LONG ISLAND TRAVELER OFFICE, C. 1895. One of the older North Fork newspapers, the *Traveler* was purchased by Joseph N. Hallock (1861–1942) in 1889. The office was in the right-hand side of the building located on Traveler Street just south of the railroad tracks. Among those pictured in front of the *Traveler* office are Lew Wilkinson, Joseph N. Hallock, Lucy Hallock, and Ella B. Hallock. In front of the left-hand wing of the building is Frank Wells, who sold eggs.

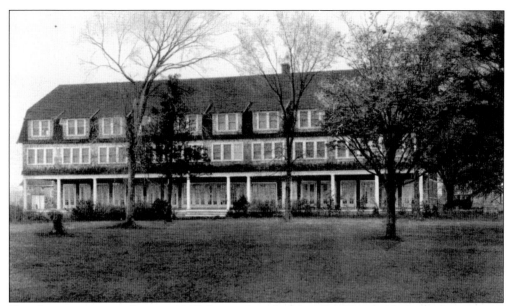

THE ARSHAMOMAQUE INN, C. 1925. Located on the bay side of Southold, the Arshamomaque Inn was owned and developed by Bennett De Beixedon (1889–1935). De Beixedon, scion of a wealthy Franco-American family, was the grandson of *Brooklyn Times* founder George C. Bennett and the developer of Beixedon Estates, a summer colony in Southold that still exists today. The Arshamomaque was opened for business in June 1921 and quickly became a popular summer resort. Just 20 years later, in July 1941, it was destroyed by fire.

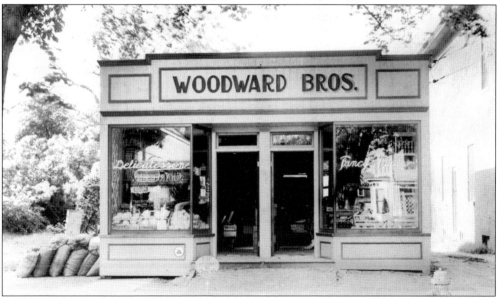

THE WOODWARD BROTHERS MARKET, 1938. Opened in the late 1930s, the Woodward Brothers store was located west of the Henry W. Prince Building on the north side of Main Street. The store replaced the Fanning house, a Victorian residence that previously had stood on the site. Woodward Brothers was operated by Bill (b. 1908) and Stuart (b. 1916) Woodward of Mattituck. By 1952, the building was occupied by a Royal Scarlet Store. In more recent years, it was home to an auto parts store and a café.

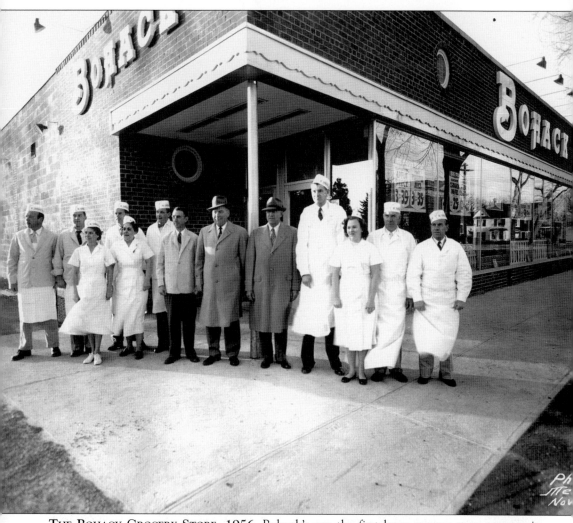

THE BOHACK GROCERY STORE, 1956. Bohack's was the first large grocery store to open in Southold, and it was a sign of the modern era. Originally located in a smaller building farther west on Main Street, Bohack's acquired the Albertson House property for its new building *c.* 1955. Pictured just prior to opening in November 1956 are, from left to right, Howard Quarty, John Oliver, Florence Harmon, Joseph Eugester, Lorraine DeAlbertis, Clifford Scholl, Charles Bennett (grocery manager), William Heins (grocery district manager), William Sweetman (meat district manager), Gilbert Michaelis (meat manager), Beverly Lehr, Ernest Yohk, and John Thompson. Today, the Southold IGA occupies the building.

Seven

SCHOOLS

THE LOCUST GROVE SCHOOL, C. 1890. As did many small communities, Southold began its educational services by establishing small community schools. These schools, which served all the small villages and hamlets in the town, began to disappear in the early 20th century. Before the era of publicly supported higher education, academies across Long Island served the needs of those who wanted their children to have a more extensive education. Southold village was no different. By 1906, the first high school had been established and Southold was on its way into the modern era of American education. Built in 1819, the Locust Grove School was moved in 1835 to the present site of the triangular park (Memorial Park), located on Main Road at the western entrance to Southold hamlet. This building was known as the Sodom School because when Walt Whitman briefly taught there, he was denounced by Rev. Ralph Smith, the minister of the Presbyterian church, as "a sodomite." The school was closed in 1900 and sold in 1902. Following that time, it was moved to a potato field and used to store brussels sprouts by a local farmer before collapsing after years of neglect.

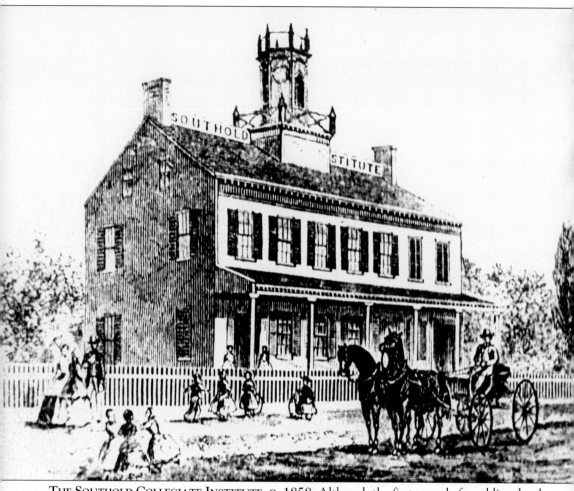

THE SOUTHOLD COLLEGIATE INSTITUTE, C. 1858. Although the first record of a public school in Southold appears in 1794, the Southold Institute was the first to offer a level of higher education to locals when it opened as the first academy in 1834. By 1858, it was reorganized as the Southold Collegiate Institute, operated by Cordello D. Elmer, principal, and Lucie A. Hale, preceptress. The institute taught all manner of subjects, including English, Greek, Latin, French, bookkeeping, and primary education. The school operated until 1863 when it was acquired to become the first St. Patrick's Catholic Church.

THE SOUTHOLD ACADEMY, C. 1900. Built to replace the defunct Southold Collegiate Institute, the second academy was opened in 1867 under the auspices of the trustees of the Presbyterian church. Located on Hortons Lane, the academy was a bastion of higher learning until 1902, when the Southold High School was opened. Following its closure, the academy served as a business school from 1907 to 1937. Today, it houses Academy Printing.

THE SOUTHOLD UNION SCHOOL, C. 1895. The Union School was built in 1870 on the site of the present Southold firehouse. The school was purchased by Fred Hummel who moved the majority of the old building up to Soundview Avenue, enlarged and renovated it, and opened it as the Paumonok Inn. One of the wings fell off during the move. It was left where it fell and was made into a house for the Grattan family.

SOUTHOLD HIGH SCHOOL, C. 1906. With the advent of fully funded state education, new schools began to spring up across eastern Long Island in the late 19th and early 20th centuries. The new Southold school was opened in 1902, following the consolidation of the smaller local school districts. John A. Bliss, who lived on Maple Lane, was the supervising architect. The school did not attain the rank of high school until 1906.

SOUTHOLD HIGH SCHOOL, 1956. By the 1920s, the population of Southold had grown to a point that made enlarging the 1902 High School Building a necessity. Due in large part to the efforts of local resident Alfred H. Cosden (1873–1962), a 60-foot wing was attached to the north side of the original building in 1923. Then, in 1937, a matching wing was attached to the south side. Following this work, the old school was redone and incorporated as the new center section. The new school opened its doors in the fall of 1938.

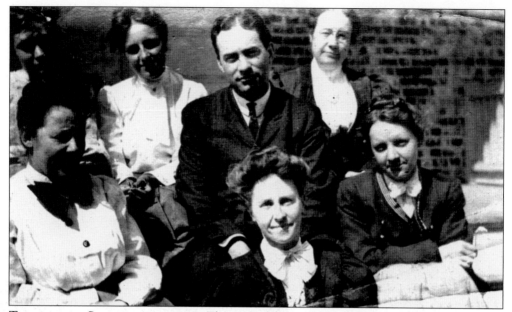

TEACHERS OF SOUTHOLD, C. 1910. This rare photograph depicts some of the teachers who taught in Southold during the first quarter of the 20th century. The are, from left to right, as follows: (first row) Ms. Polly (later Mrs. Gildersleeve), Margaret Deale, and Elizabeth "Daisy" Terry; (second row) Mr. De Gelleke; (third row) Miss Vaughn, Miss Brainerd, and Miss Stout (later Mrs. Herbert Hawkins).

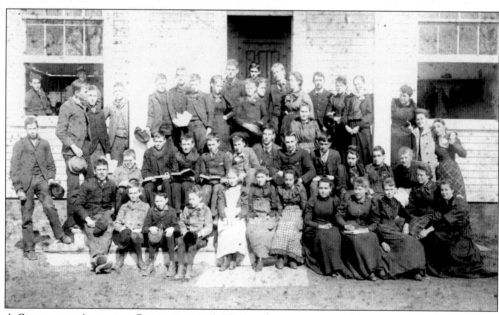

A SOUTHOLD ACADEMY CLASS, C. 1885. Notice the great range of ages served by the academy.

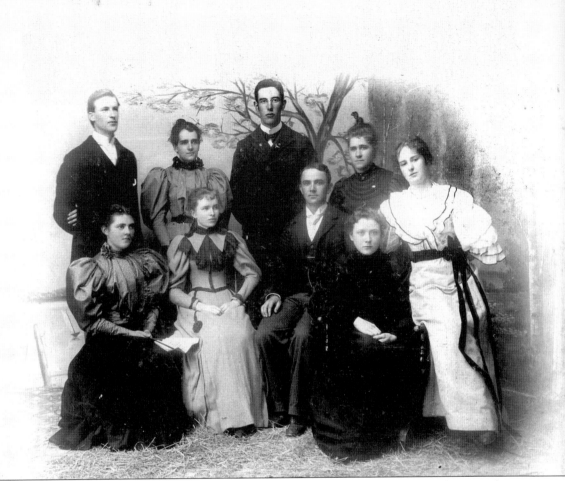

THE GRADUATING CLASS, SOUTHOLD ACADEMY, 1894. The students shown here are, from left to right, as follows: (first row) Grace Payne, Ada Billard, Henry Ehmer, Amy Sturges, and Anna Wells; (second row) Ted Shipherd, Desiah Fanning, Harry Payne, and Mabel Boisseau.

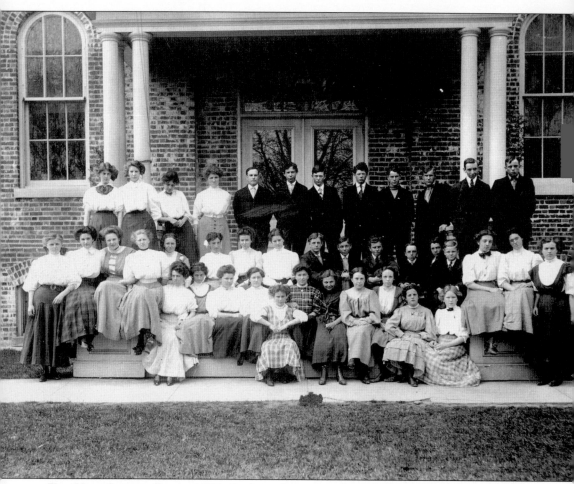

THE HIGH SCHOOL CLASS, 1908. Students shown here from the high school class of 1908 are, from left to right, as follows: (first row) Rose Mahoney, Elise Hommel, Florence ?, Ethel Beebe, Hattie Booth, Violet Beebe, Miriam Fickerson, Mary Conklin, Barbara Bliss, Gladys Bergen, and Nellie Danz; (second row) Caroline Taylor, Caroline Goldsmith, Arlien Appleby, Rose Case, Mary Kenny, Rose Gagen, Louise Fitz, Ernestine Howell, Israel Terry, Bill Hoinkis, Dan Grattan, Germond Cochran, unidentified, Clare Van Dusen, Edith Breitstadt, Ethel Grathwohl, and Ellie Terry; (third row) Hilde Leicht, Marion Terry, Winifred Brainerd, Jessie Clark, Elwood Schafer (Principal), Claude Hodgins, Dave Griswold, Gilbert Horton, Carlisle Horton, Elton Booth, Harold Tuthill, and Dick Vail.

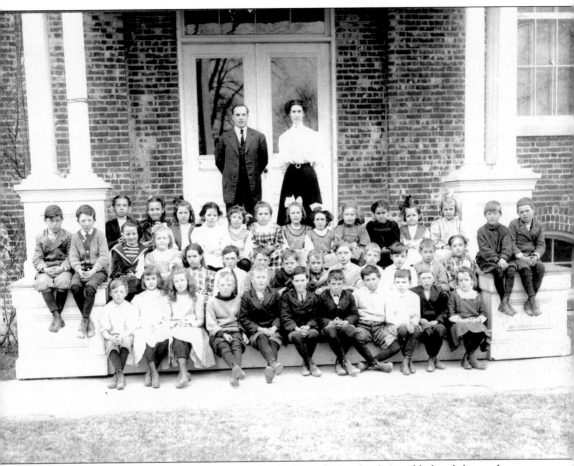

A SECOND-GRADE CLASS, C. 1910. Elwood Schafer and Miss Stark stand behind the students, who are, from left to right, as follows: (first row) Lionel Burt, Murlin Young, Delephine Mitchell, Ed Horton, Joseph Grattan, Francis Burke, John Kelly, Willie Franklin, Ferdinand Bauman, Raymond Donahue, and Susie May; (second row) John Merwin, Everett Goldsmith, Letitia Canfield, Frieda C. Williams, May Bixby, Frederick Case, Gordon Taylor, Baylis Munch, Ralph Glover, Lyman Bliss, Alfred Booth, Joseph Bond, Joseph Turner, Ruth Bixby, George Baker, and Joshua Overton; (third row) Katie Doroski, Carolin Franklin, Irene Griswold, Jean Murry, Lucy Kanold, Nellie Brush, Lilly Hafner, Madeline Carroll, Monica Grattan, Agnes Gordon, Dorothy Van Wyck, and Alice Bond.

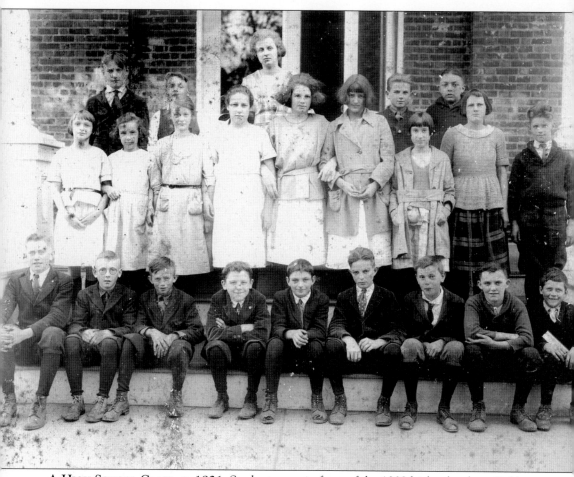

A HIGH SCHOOL CLASS, C. 1921. Students pose in front of the 1902 high school, on Oaklawn Avenue. From left to right are the following: (first row) Carliss Coley, Dan Smith, Bill Zebroski, James Cogan, Tom Conway, Charles Vreeland, Harry Weigand, George Stelzer, and Clifford Tillinghast; (second row) Katherine Hilliard, Harriet Dickerson, Martha Gallagher, Caroline Stelzer, Flora Albertson, Marguerite Erhardt, Bernice Simon, Margaret Baker, and Fred Bridge; (third row) Fred Boergesson, Joe Bond, Miss Johnson, Steve Romanski, and Frederic C. Prince.

Eight
LEISURE

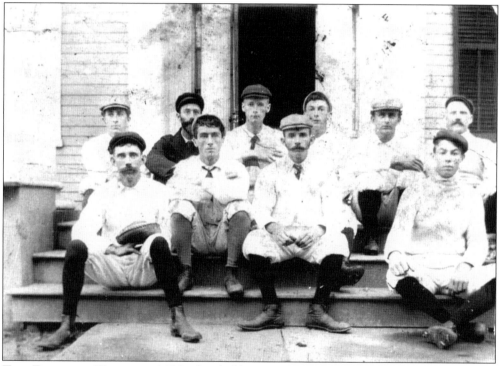

THE FOOTBALL TEAM, C. 1880. Southold was a community that reveled in its leisure activities. If people were not working, they were out playing baseball, going for a ride, or just relaxing in the quiet countryside. Baseball was immensely popular, with early teams participating in series across Long Island and at county fairs, even exciting players from professional clubs to participate locally. Other sports—golf, football, and bowling—proved to be well received by just about everyone. Special clubs and events, such as the horse show, brought a new level of recreation to Southold. Though baseball was its first love, football was a close second for Southold. From left to right are the following: (first row) Frank Gagen, John Hand, John Carroll, and ? Smith; (second row) H. Rackett, Joe Case, Jake Hipp, Mike Hand, Irv Tuthill, and Jessie Case.

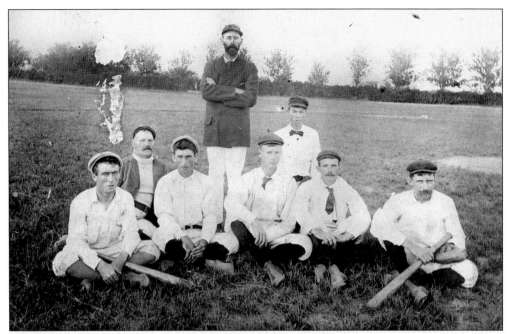

THE PECONIC BASEBALL TEAM, 1885. Dating to as early as 1867, the team was being managed by Dr. Josiah Case (standing, 1865–1930) by the late 19th century. It was fairly successful, occasionally attracting outside players, including the well-known New York Giants pitcher Huyler Westervelt (1869–1949). Among the players shown here are, from left to right, Johnny Hand, Jesse Case, Jake Hipp, Johnny Carroll, a member of the Gagen family, and others.

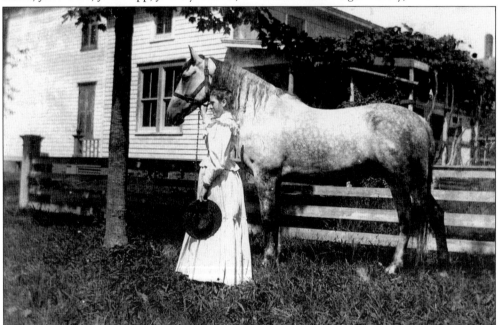

AT REST, C. 1895. Amy Sturges (1876–1940) is shown here with her father's horse at the family home, located on the corner of Oaklawn Avenue and Main Road, in the background. Her father, Richard Sturges (1847–1920), was a local carpenter who built many buildings in Southold.

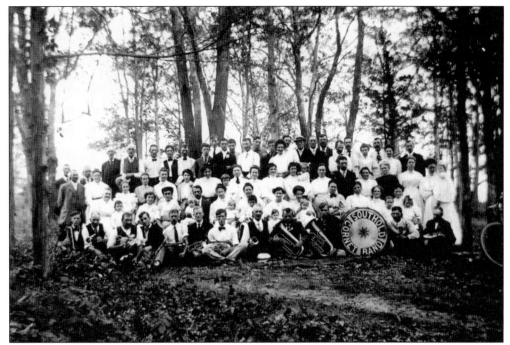

THE SOUTHOLD CORNET BAND, C. 1900. The Southold Cornet Band was begun prior to 1882, the year it performed at the Fourth of July celebrations in Southold. The band often played in Belmont Hall, where it leased space. By the early 1890s, the band was under the direction of George Ellis Horton (b. 1868), son of the noted composer and music professor David Philander Horton (1827–1902). Here, members of the band pose in the woods at Southold.

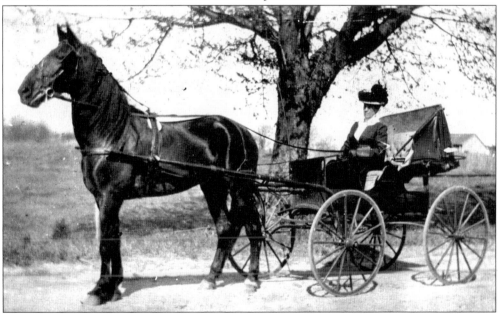

ON THE ROAD, C. 1900. Hattie S. Jefferson (b. 1850) prepares to go for a drive near her home in Peconic. Her husband, Robert Jefferson, ran Jefferson's General Emporium, located on Peconic Lane. Along with housing the post office, the store carried all measure of goods.

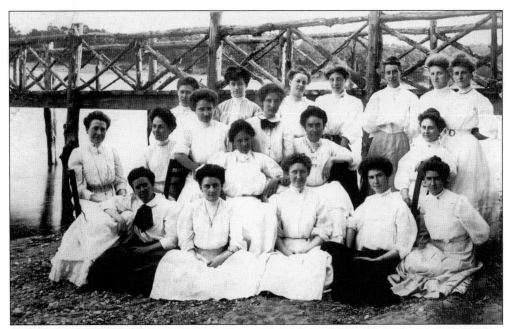

THE OLD MAIDS CLUB, C. 1900. The Old Maids Club was a local social group. Pictured in front of the bridge to George Harper's house, on Youngs Avenue, are, from left to right, the following: (first row) Lucy Hallock Folk, Louise Welch, Alice Santry, Josephine Stark Cunningham, and Mabel Boisseau Conklin; (second row) Amy Sturges, Alice Stokes, ? Vaughn, Winifred Brainard, Eleanor Howell, Margaret Harper, and ? Deale; (third row) Sadie Schafer, ? Golder, Puss Terry, Bertha Corey, Abbie Teague, and ? Clark.

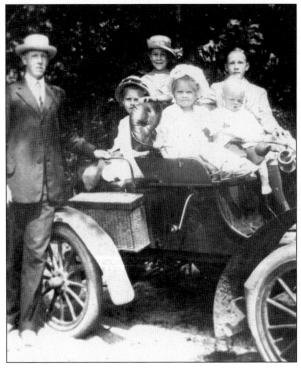

THE OLDSMOBILE, C. 1914. John Van Mater Howell and family are shown with his 1905 Oldsmobile, the first automobile on the East End. The vehicle was used by the Howell family, who lived on South Harbor Road from 1905 through 1913, when they purchased a Buick Runabout to replace the Oldsmobile.

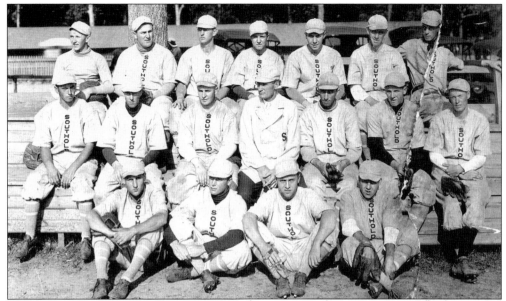

THE SOUTHOLD BASEBALL TEAM, 1915. Each year, teams from across Long Island competed at the annual Suffolk County Fair in Riverhead. Pictured on the fairgrounds is the Southold Baseball team, from left to right, as follows: (first row): Harold Booth, Leo Thompson, Bill Schwicker, and Al Salmon; (second row): Frank Moffat, Chas Turner, Rick Cochran, Charles Gordon, Jack Diller, Bill Griswold, and Jack Turner; (third row): Myron Glover, Bob Carey, I. P. Terry, Wes Prince, Clem Booth, Ed Diller, and Let Albertson.

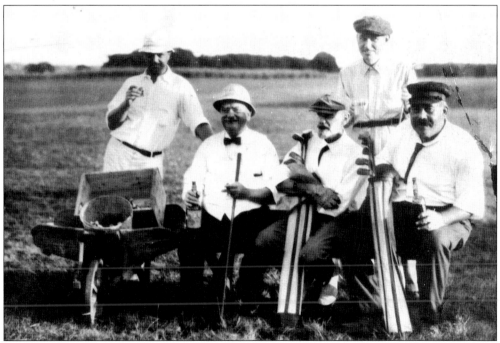

ON THE COURSE, C. 1925. There is nothing like a little snack and drink between holes. This group is probably at the Reydon Golf Club, which was established by Edwin H. Brown (1851–1930) of Brooklyn. What these gentlemen are eating and drinking remains a mystery.

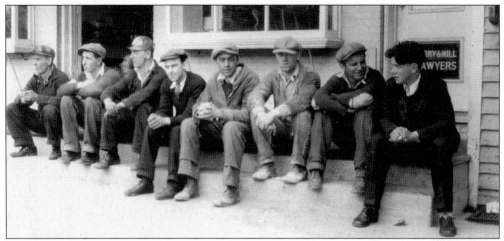

ON THE STEPS, C. 1925. These young men take a rest and socialize on the steps of Henry L. Jewell's Butcher Shop. From left to right are Francie Weygand, "Oose" Ostroski, Harry Weygand, Joseph "Pickle" Stelzer, Frederic C. "Hummer" Prince, Charlie Weygand, Jo "Covey" Krukowski, and Francis "Possum" Thompson. The door to Terry and Hill's law office is on the right.

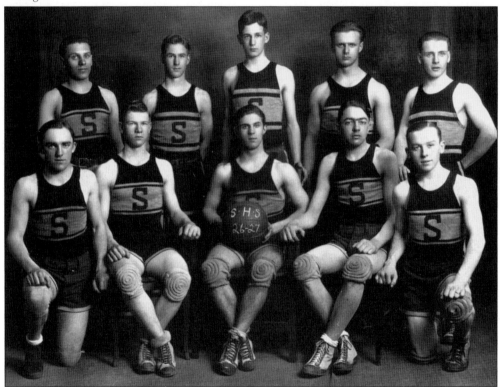

SOUTHOLD'S BASKETBALL TEAM, 1926–1927. Basketball was a popular sport in Southold, and the 1926-1927 season was one of the best on record. The team won 15 of 22 games and scored 674 points. From left to right are the following: (first row) George Stelzer, Elmer Ruland, Fred Bridge, Fred C. Prince, and James Cogan; (second row) Ernest Dickerson, Dwight Bridge, Lyle Meredith, Henry Kress, and Joseph Bond.

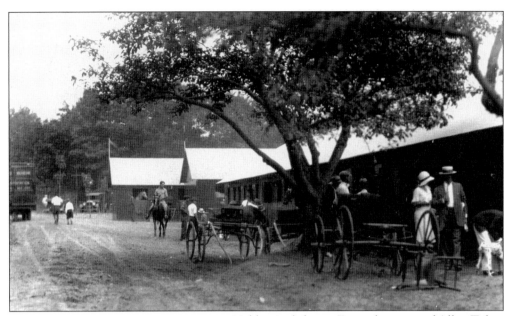

AT THE SOUTHOLD HORSE SHOW, 1930. Held at Lighthouse Farm, the estate of Allen Tobey (1889–1959), the show Southold Horse Show was considered one of the best run in the circuit. Though it lasted for only two seasons, it was a very popular event for both exhibitors and the general public. Pictured is the massive stable complex that was built for the event.

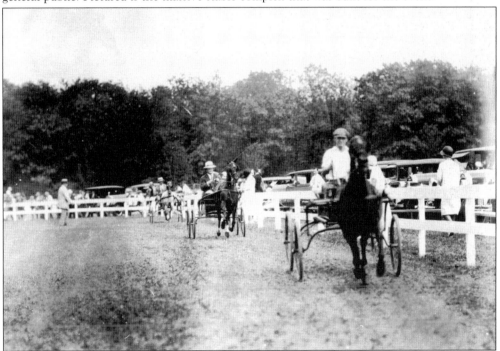

PREPARING FOR THE HORSE SHOW, 1930. In the ring at Lighthouse Farm, trotters prepare for the day's activities at the Southold Horse Show. Though successful in boosting the reputation of Southold and its wealthier residents, the show was a financial liability and ceased to exist after 1931.

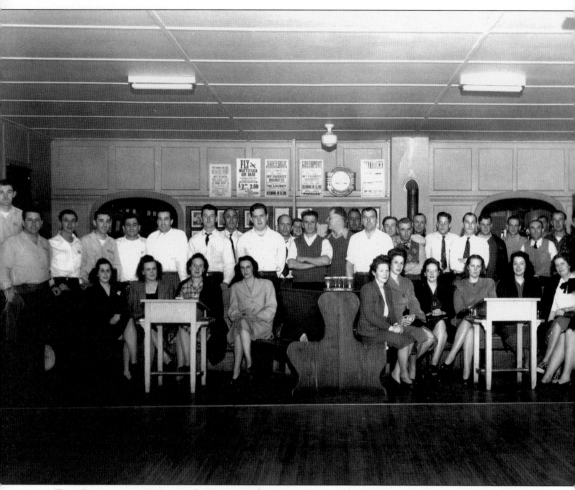

THE BOWLERS, 1947. At the Mattituck Lanes during the 1940s and 1950s, many Southolders enjoyed at least one evening a week of bowling. In this 1947 photograph are, from left to right, the following: (first row) Hope Albertson, Libby Albertson, Beverly Bennett, Marie Smith, Doris Warner, ? Michaelis, Pauline Howell Williams, Doris Williams, Irene Dickerson, Rose Bennett, and unidentified; (second row) Gil Michaelis, Vince Warner, John Kroleski, Charles Bennet, Joe Gradowski, unidentified, Clement Thompson, Cory Albertson, Lester Albertson, William Rafford, unidentified, Alex "Bosko" Blosich, unidentified, Fred C. Prince, Lloyd Dickerson, William Smith, Harry Gagen, unidentified, Bud Williams, Art Gagen, Chet Berry, Frank Berry, Charles Gagen, two unidentified people, Ben Fischer, and Bill Richmond.

Nine

BOATING AND THE BEACH

PREPARING FOR A SAIL, 1889.
The original settlers of Southold arrived here by boat, and since that time, sailing has been a way of life. Competing on the water proved to be most popular, with annual regattas and races sponsored by the Southold Yacht Club and others occurring during the summer. Two-day sails, filled with good times and great food, were also fashionable with local residents. Beach picnics were events that were looked forward to by all, whether planned or spur of the moment. The thought of eating food, cooling off in the water, and relaxing in the shade under handmade arbors made everyone look forward to the summer. Here, a group of men, women, and children prepare to depart for a day of sailing around eastern Long Island on August 27, 1889. The group was called We, Us, and Company.

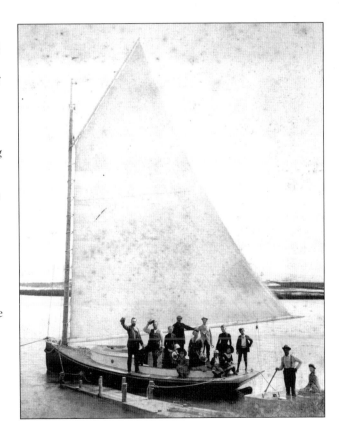

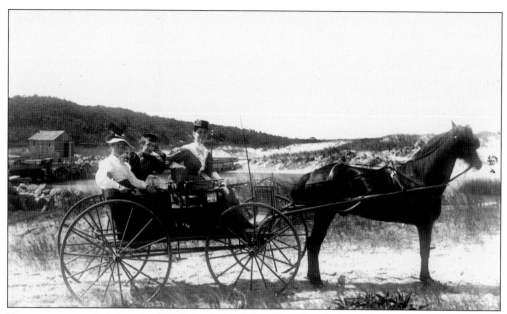

RIDING AT THE BEACH, C. 1890. Members of the Wells family pause for a photograph near the site of the Peconic Tidal Mill, at Goldsmith's Inlet on the sound. In the left background are the stone walls built to help control the flow of water to the mill.

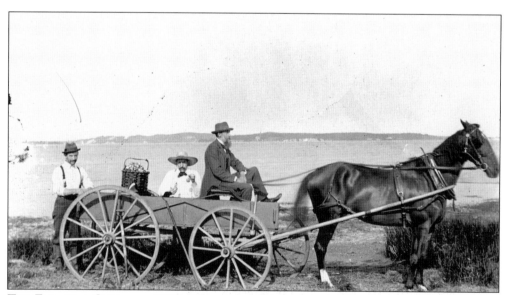

THE END OF A QUEST, C. 1890. After a day's labor, these hardworking men have acquired enough steamer clams for all. This photograph was taken from the beach on Great Hog Neck looking toward Shelter Island, in the background.

A Two-Day Sail,
c. 1895. A popular event
in the late 19th and early
20th centuries, the two-
day sail was looked
forward to by many. Here,
a number of men, women,
and children are shown
aboard the sailing vessel
the *Harp*, captained by a
man referred to as Capt.
Maynard, possibly
William M. Maynard.

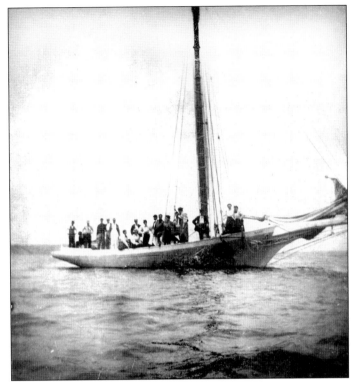

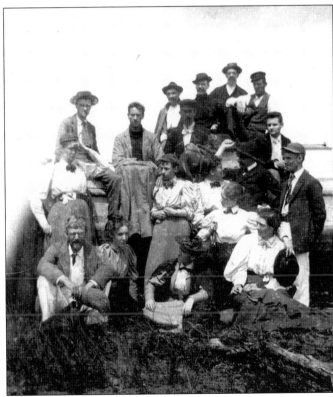

A Two-Day Sail,
c. 1895. The group is
shown preparing to board a
vessel and head off for a
two-day sail. Among those
pictured are Ella Boldry
Hallock, Joseph N. Hallock,
Capt. Maynard, Jane Smith
Fleet, Fred Williams,
Eleanor Howell, Lucy
Hallock, Da Edwards,
Henry Elmer, May Case
Sinclair, and Minnie
Terry Smith.

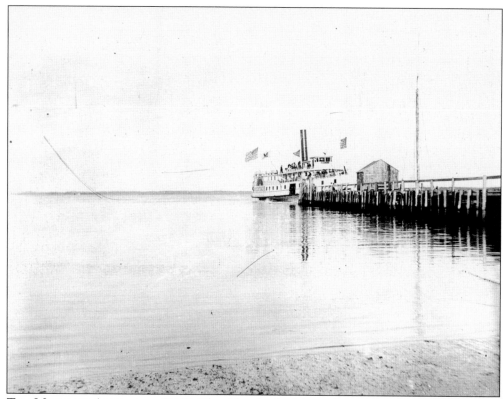

THE MONTAUK ARRIVES, C. 1895. The side-wheeler *Montauk* arrives at the Southold Dock. Steamers such as this one were common along the shores of Long Island during the late 19th and early 20th centuries. The dock was demolished in 1954.

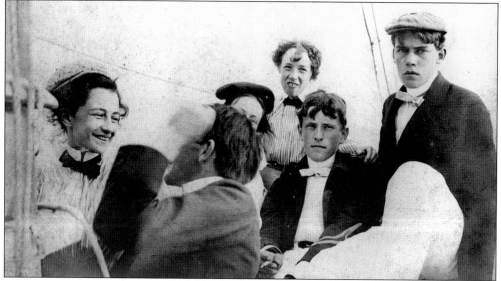

OUT FOR A SAIL, C. 1895. A group of young men and women have a good time while out for a sail. The message on the reverse reads, rather oddly, "I shall always regret that there was no photographer on board to record the exceedingly funny thing you said."

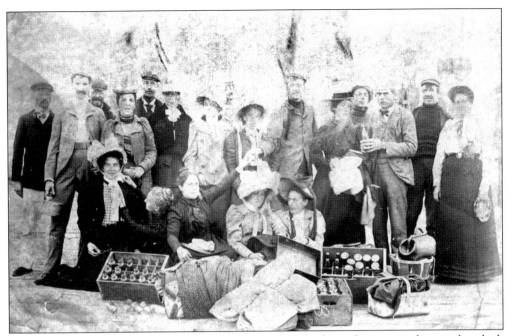

AT THE DOCK, C. 1890–1900. A group ready for a two-day sail poses on the wooden dock before departing. In the foreground are the cases of food and drink, including sarsaparilla and root beer, that will make the sail complete.

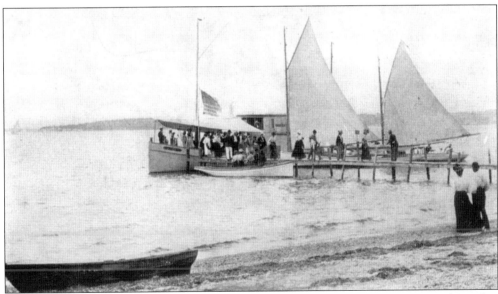

BULLOCK'S PARADISE POINT, C. 1900. George W. Bullock was the proprietor of Paradise Point, a sailing and steamer service likely located at the actual Paradise Point. By this time most of Paradise Point had been purchased by Edwin H. Brown (1851–1930), noted attorney and golf course developer.

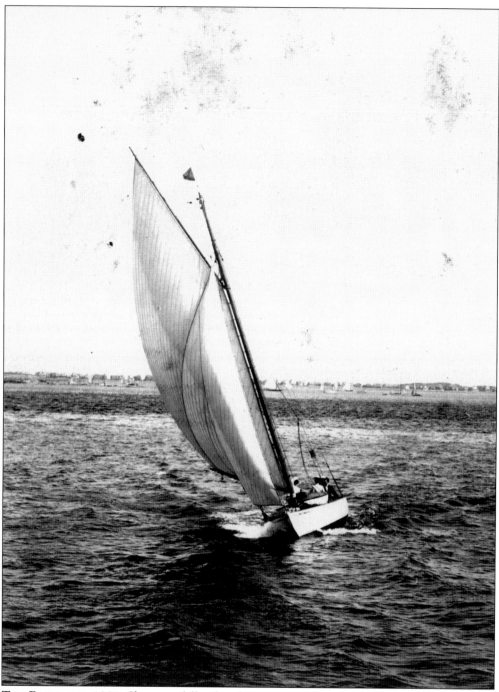

THE BARNACLE, 1901. Shown at full sail and out on one of the bays, the *Barnacle* was owned by none other than Peconic school painter Edward A. Bell (1862–1953). It is said that Bell's initial arrival in Peconic had more to do with sailing than painting.

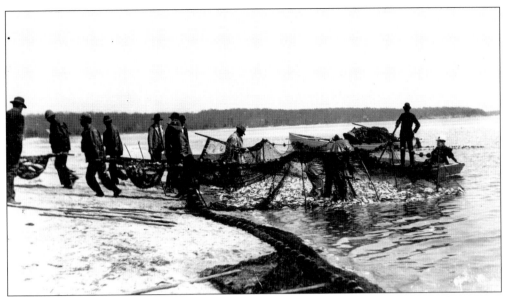

SEINING ALONG THE BAY, C. 1901. Dressed in their mildly waterproof gear, fisherman at Nassau Point Beach bring in the day's catch of fish, to be used for fertilizer. Nets were drawn to the shoreline, and then pitchforks were used to load the fish into box wagons, which carried the fish to local farms for spreading in the fields.

THE SEGAYAN CLUB CLUBHOUSE, C. 1902. Founded by the Appleby family of Peconic, the club was created so that friends and neighbors would have a place to get together and picnic along the shore. Membership was limited to just 20 families, who would meet on the first Saturday of the month for dinner at the clubhouse. The club was named for Segayan, the last Indian who lived upon Indian Neck. Here, Jack Appleby and Rosalind Case Newell (1890–1985) are pictured in front of the clubhouse.

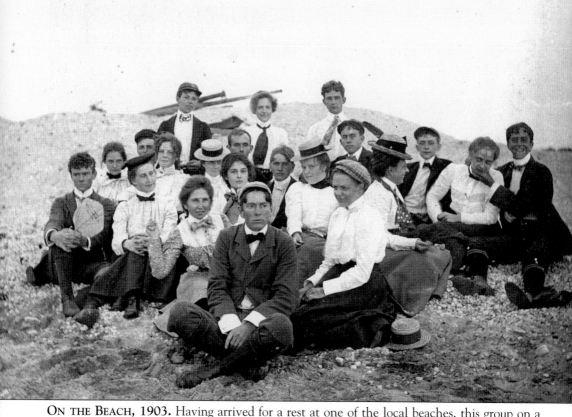

ON THE BEACH, 1903. Having arrived for a rest at one of the local beaches, this group on a two-day sail in 1903 relaxes while having a picture taken. In the group are Rose Dixon, Ellen Dixon, Henrietta Griswold, Henry Goldsmith, Jack Diller, Nell Williams, Ezra Williams, Annie Corey, Fred Scriefer, Jane Diller, Caroline Leicht, John Wells, Clinton Voorhees, Dora Fickeissen, Florence Fickeissen, Fred Leicht, Tom Owens, Roscoe Corey, Josie Case, Grace Wells, Louise Williams, Bill Williams, Warren Griswold, and Ed Fickeissen (b. 1887).

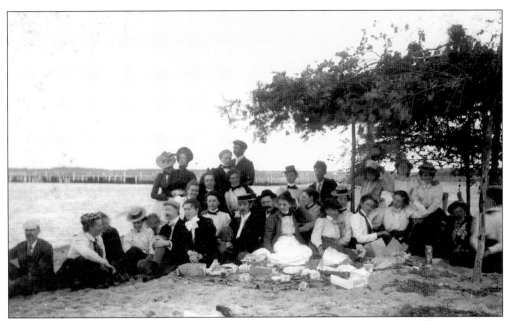

PICNIC TIME, C. 1910. Beach picnics were a very popular activity in the late 19th century, especially on eastern Long Island. Here, a group relaxes on J. B. Terry's beach, near the town dock, which can be seen in the background. The beach arbor, built by hand, was a phenomenon found on both the North and South Forks of Long Island.

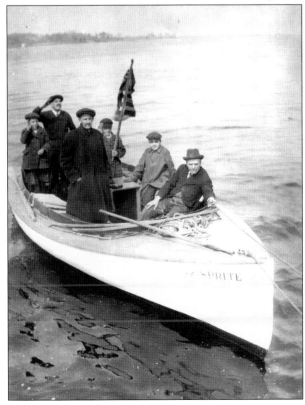

THE *SPRITE* ARRIVES, C. 1915. Owned by Albert T. Dickerson (b. 1873), the *Sprite* is shown full of passengers arriving at its destination. From left to right are Ernie Dickerson (b. 1904), George H. Dickerson (b. 1869), Henry Wines (b. 1854), Henry P. Dickerson (b. 1903), Ray Dickerson (b. 1905), and Albert T. Dickerson.

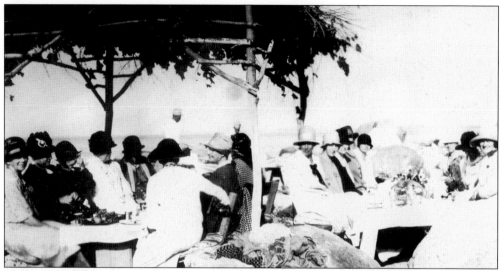

A CLUB PICNIC ON THE SOUND, C. 1932. A popular local charitable group, the Tuesday Morning Club met at a different member's house each time. Here, the club is meetings at Loraine B. Cosden's beach, on the Sound. The Cosdens had a large estate there, and Loraine Cosden served as chair of the club for 16 years. Among those identified are Minnie Smith, ? Marshall, ? Mitchell, Louise Rich, Edith Mills, Edna Cahoon Booth, Adah Smith, and Phoebe Bridge.

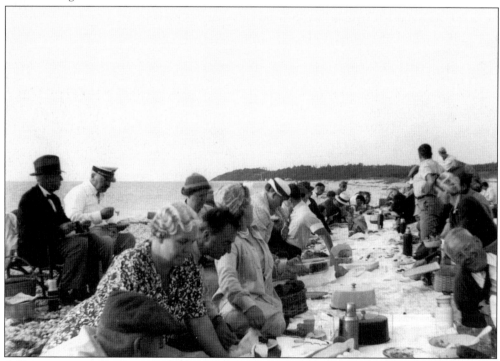

A PICNIC ON THE SOUND, C. 1935. Large-group picnics like this one had become the norm by the 1930s. An inexpensive and entertaining way to spend an afternoon, many families participated in them. Among those enjoying a feast on the beach at Peconic Inlet are J. N. Hallock, Tom Currie-Bell, Genevieve Albertson, Ethel Dickerson, and Adelaide Hill.

THAT IS THE BEST ONE YET, C. 1940. A pleasant day of sailing is permeated by a good joke told by Thomas Currie-Bell, aboard the vessel of Ann and Leo Roon. Among those on board are Joseph N. Hallock, Virginia Terry Salmon, and Ann Currie-Bell.

LEARNING TO ROW, C. 1940. Out on the bay, Dan Overton tries to get a handle on rowing his boat back to shore.

READY FOR THE RACES, C. 1941. Amateur and professional sailors ready their vessels at the Southold Dock in preparation for the Southold Yacht Club's annual competitions.

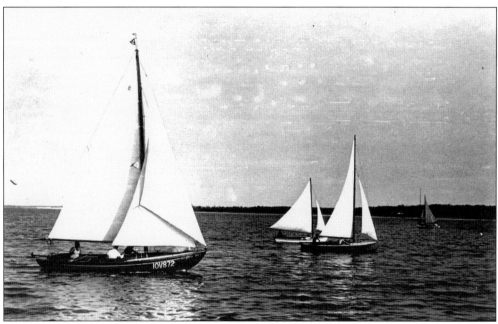

IN THE RACE, 1943. Southold Yacht Club members test their skill during the club's annual August races. In the left foreground is the *Bluebell*, owned by painter Thomas Currie-Bell (1873–1946).

AT THE DOCK, 1943. For years, the yacht club used the Southold Dock, at Founder's Landing, as a place to organize its races. Here, participants and onlookers, as well as sunbathers, wait for the races to begin.

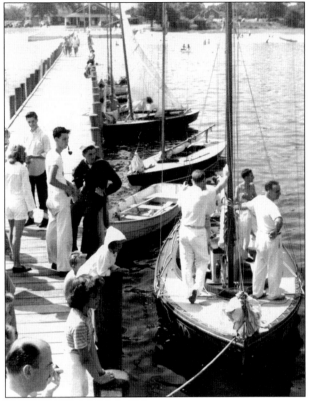

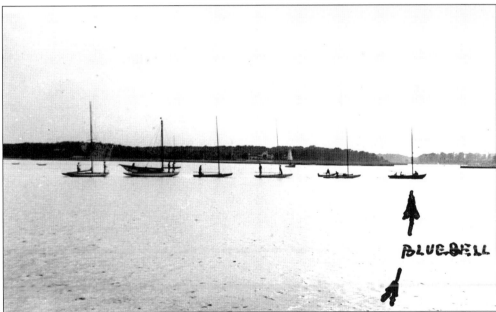

IN TOW, 1944. The *Bluebell* was one of the most successful boats that raced with the Southold Yacht Club in the 1930s and 1940s. It could always be relied upon to show well during the season, even if that meant only helping out others. The *Bluebell, on the right,* tows five stranded vessels to shore during a dead calm in August 1944.

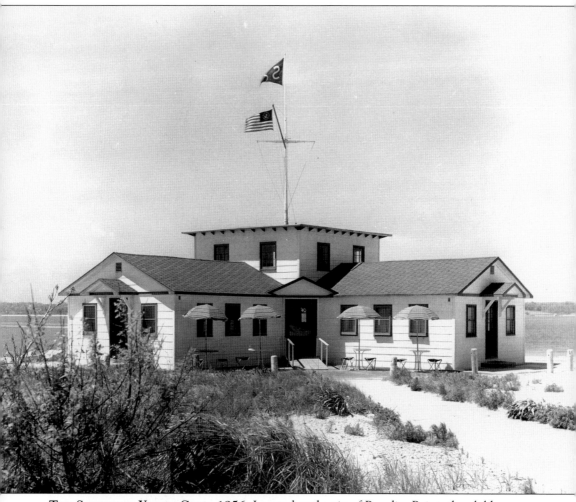

THE SOUTHOLD YACHT CLUB, 1956. Located at the tip of Paradise Point, the clubhouse was a gathering place for all those interested in sailing. In later years the site became too dangerous to launch boats, and the club sold the property and moved to a site near the opening of Goose Creek. Today, the building is privately owned.

Ten
AUTHORS AND ARTISTS

ON HIS BOAT, C. 1890. Southold was privileged to be one of the select places to which artists from all over came to live and paint. Beginning in the late 19th century, noted New York artists such as Benjamin R. Fitz, Edward August Bell, and Henry and Edith Prellwitz began a colony of artists and established a tradition that continues to the present day. The North Fork, especially in and around Peconic and Southold, elicited some of the best images that these and other artists ever created. Today, the works created by artists of the Peconic school continue to receive praise and recognition throughout the United States. Bell (1861–1953), an important American painter and participant in the Peconic school of artists, is shown here aboard one of his boats. He married Julia Overton (1879–1966), a local resident, and spent much of the second half of his life living and painting on the North Fork of Long Island.

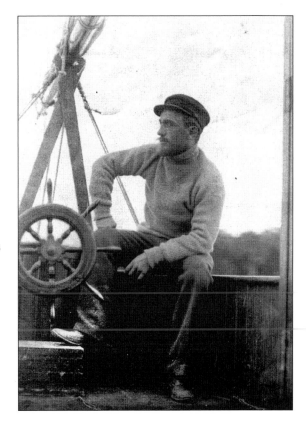

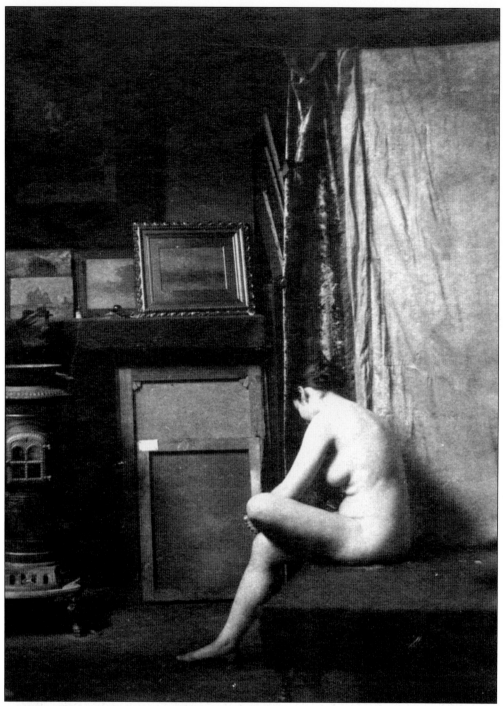

A MODEL IN THE STUDIO, C. 1890. A model poses in what is believed to be the studio of Benjamin Rutherford Fitz (1855–1891), in Peconic, Long Island. Paintings, including those depicting coastal scenes off Long Island, are shown stacked on the left.

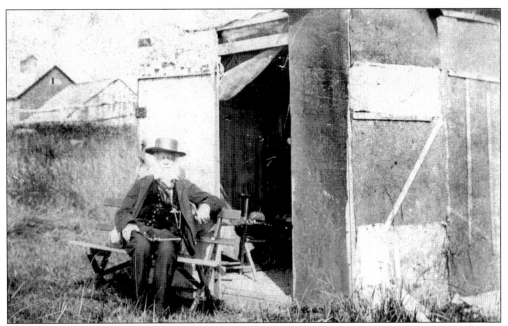

JOHN BURROUGHS AT REST, C. 1897. Noted essayist John Burroughs (1837–1921) came to Long Island for a little rest between his literary activities. He is shown here seated outside his little shack, enjoying a summer's day on Nassau Point in Peconic.

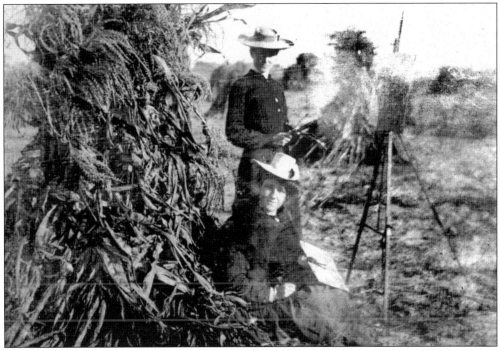

PLEIN AIR PAINTING, C. 1900. Caroline "Dolly" Bell (1874–1970) is depicted here painting from life with a friend, possibly Julia Wickham (1866–1952), another artist who lived in nearby Cutchogue. Bell was a member of the Peconic school of artists and was known for her paintings of scenes depicting the North Fork of Long Island.

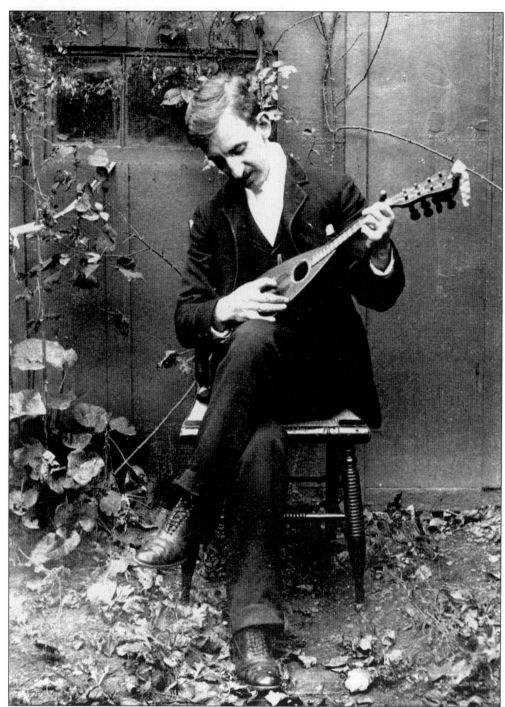

ARTIST AT PLAY, C. 1901. David Cunningham Lithgow (1868–1958) was a painter and sculptor who came to America from Scotland in 1888. During his long career here, he became noted for his large murals and magnificent sculptures. A great friend of the Boldry-Hallock family, Lithgow spent a great deal of time in Southold painting local scenes, as well as working on specific commissions for local residents.

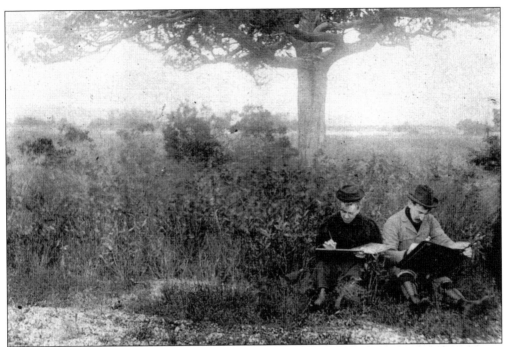

ARTISTS SKETCHING, C. 1901. Painter David Cunnigham Lithgow (1868–1958) and local resident Lucy Hallock Folk (1869–1946) are shown sketching at a very popular location for artists in Southold: Cedar Beach, located on Great Hog Neck.

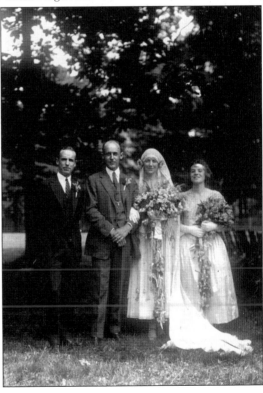

A PRELLWITZ MARRIAGE, 1923. Edwin Mitchell Prellwitz (1896–1976), son of noted Peconic school artists Henry Prellwitz (1865–1940) and Edith Mitchell Prellwitz (1864–1944), is depicted here, second from the left, on his wedding day. Like his parents, he was also a painter but was perhaps best known for his work as a landscape architect. With him are, from left to right, Jean Briggs, Eunice Browning Prellwitz (1897–1988), and Kay Salmon (1901–1994).

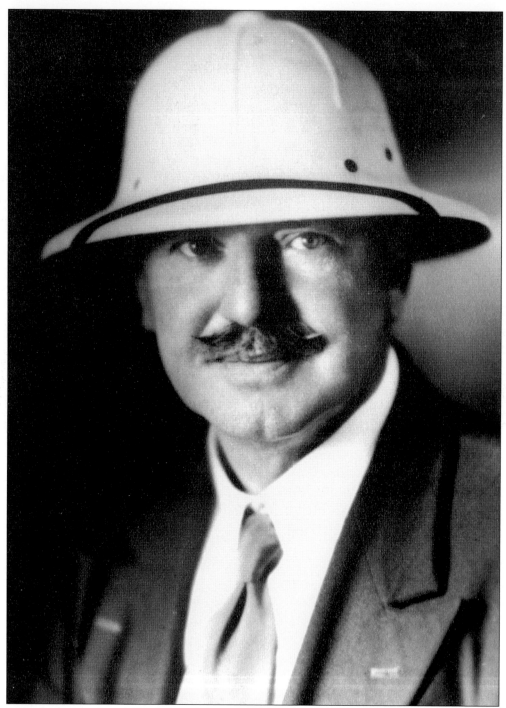

"THE EXPLORER," C. 1931. Painter Thomas Currie-Bell (1873–1946) looks as if he should be hunting in some dark part of Africa, but in fact he was living in Southold. Trained in Scotland, Currie-Bell moved to America in 1929 to marry his sweetheart, Ann Hallock (1897–1964). A noted portrait painter, he traveled up and down the East Coast, filling numerous commissions.

AT THE STUDIO, C. 1935. Thomas Currie-Bell enjoyed painting is his studio, which was located at Paradise Point, where his wife's family owned a good deal of land. The building was designed to take advantage of the natural light and a beautiful position on the water. The studio was torn down sometime in the late 1960s.

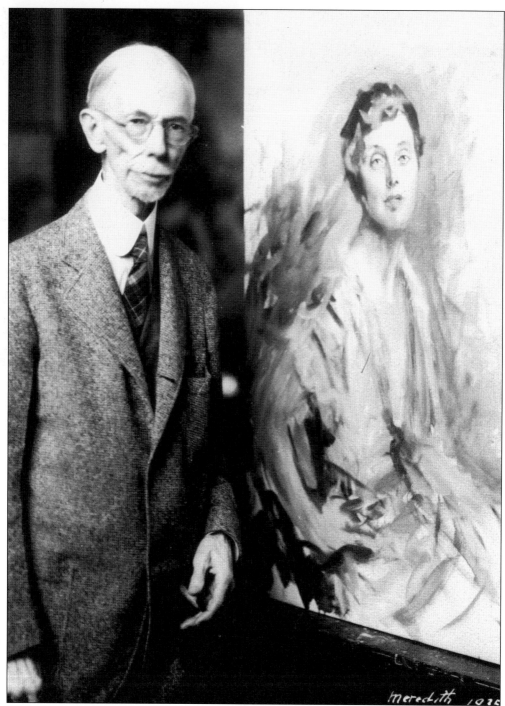

WILES AT REST, 1935. Irving Ramsey Wiles (1861–1948) is shown with a portrait in his studio in Peconic, Long Island. Wiles was the son of noted painter and art instructor Lemuel Maynard Wiles (1826–1905) and became one of the Peconic school's most noted members. He arrived here in 1895 and spent the next 50 years using his brush to depict the North Fork of Long Island.

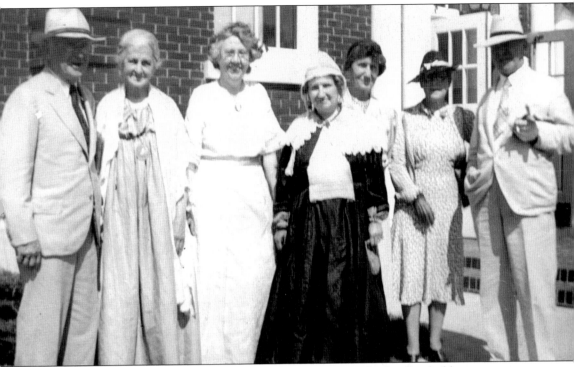

THE PECONIC SCHOOL, 1940. In 1940, in conjunction with the Southold tercentenary celebrations, a special art exhibition was held. Many local artists participated, including some of the more noted members of the Peconic school of painters. Standing outside the Mattituck High School are, from left to right artists Edward A. Bell, Julia Wickham, Clara M. Howard, Marguerite Moore Hawkins, Caroline "Dolly" Bell, Virginia Wood Goddard, and Thomas Currie-Bell.

Bibliography

Beers, F. W. *Atlas of Long Island, New York from Recent and Actual Surveys and Records.* New York: Beers, Comstock, and Cline, 1873.

Belcher-Hyde, E. *Atlas of a Part of Suffolk County, Long Island, New York, North Side–Ocean Shore.* New York: E. Belcher-Hyde, 1902.

———. *Atlas of a Part of Suffolk County, Long Island, New York, North Side–Ocean Shore, Part of Southold, Plate 11.* New York: E. Belcher-Hyde, 1909.

Brooklyn Daily Eagle, 1841–1902.

˙Campbell, Stephen E. *Cemetery of the First Church Congregation or Society in Southold.* 1961 (unpublished). Copy held by the Southold Historical Society, Southold, New York.

Chace, J., Jr. *Map of Suffolk County, Long Island, New York.* Philadelphia: John Douglass, 1858.

Chapman Publishing Company. *Portrait and Biographical Record of Suffolk County, Long Island, New York.* New York and Chicago: Chapman Publishing Company, 1896.

Craven, Rev. Charles E. *Whitaker's Southold, Being a Substantial Reproduction of the History of Southold, L.I. Its First Century.* Princeton, New Jersey: Princeton University Press, 1931.

Currie-Bell, Ann Hallock. *Old Southold Town's Tercentenary.* Garden City, New York: Country Life Press, 1940.

Hallock, Ella B. *The Story of the 275th Anniversary Celebration of the Founding of Southold Town.* Garden City, New York: Doubleday, Page, and Company, 1915.

Haughton, Ida Cochran. *Chronicle of the Cochrans.* Columbus, Ohio: The Stoneman Press Company, 1915.

Hayes, Charles Wells. *William Wells of Southold and his Descendants.* Buffalo: Baker, Jones, and Company, 1878.

Hazelton, Henry Isham. *The Boroughs of Brooklyn and Queens, Counties of Nassau and Suffolk, Long Island, New York, 1609–1924.* Five Vols. New York and Chicago: Lewis Historical Publishing Company, 1925.

Huntting family. *The Huntting Scrapbooks.* (unpublished). Held in the Whitaker Collection of the Southold Free Library, Southold, New York.

Hutchinson, Jane Errickson. *The Descendants of Thomas Hutchinson of Southold, New York, 1666–1982.* Baltimore: Gateway Press, 1982.

Lathrop, G. P. *Peconic Park: An Exploration on Long Island.* New York: Printed for private circulation, 1883.

The Lawton Company. The *Southold-Shelter Island Register.* Auburn: the Lawton Company, 1910.

Lewis Publishing Company. *Long Island: A History of Two Great Counties: Nassau and Suffolk.* Three Vols., New York: Lewis publishing Company, 1949.

Mather, Frederic G. *The Refugees of 1776 from Long Island to Connecticut.* Albany, New York: J. B. Lyon and Company, 1916.

Moore, Freddie G. *The Descendants of Thomas Moore Sr. of Suffolk County, England.* 1996 (unpublished). Copy held by the Southold Historical Society, Southold, New York.

Newell, Rosalind Case. *A Rose of the Nineties.* Southold, New York: The Long Island Traveler, 1962.

———. *Rose Remembers.* Southold, New York: Academy Printing Services, 1976.

The *New York Times*, 1851–present.

Prince, Helen Wright. *Descendants of Captain John Prince of Southold, New York and Their Place in Local History.* Blacksburg, New Yoerk: Kopy Korner, 1983.

Prince, Mrs. Henry W. *Scrapbook.* 1880 (unpublished). Copy held by the Southold Historical Society, Southold, New York.

Salmon family. *The Salmon Record, 1696–1880.* 1880 (unpublished). Copy held by the Southold Historical Society, Southold, New York.

Sandford, Harold A. *A Collection of Genealogical Charts as prepared by Ann Hallock Currie-Bell and other Volunteers of the Southold Historical Society.* 1999 (Two Vols., unpublished). Copy held by the Southold Historical Society, Southold, New York.

Southold Free Library. *Whitaker Collection Research Files.* Held by the Southold Free Library, Southold, New York.

Southold Historical Society. *Clipping File, A-Z.* Held by the Southold Historical Society, Southold, New York.

———. *The Ann Hallock Currie-Bell Collection of Papers and Photographs.* Held by the Southold Historical Society, Southold, New York.

———. *The Ann Hallock Currie-Bell Research Committee Files.* Held by the Southold Historical Society, Southold, New York.

———. *The Charles M. Meredith Photograph Collection,* c. 1910–1966. Held by the Southold Historical Society, Southold, New York.

———. *Guide To Historic Markers.* Southold, New York: the Traveler Watchman, 1960.

———. *Local Cemetery Files.* Held by the Southold Historical Society, Southold, New York.

———. *Obituaries File.* Held by the Southold Historical Society, Southold, New York.

Tuyl, Otto Van. *Subdivision Map of Cedar Beach Park, Situate at Bayview.* Greenport, New York, 1926.

White, Adaline Horton. *The Hortons in America.* Seattle: Sherman Printing and Binding Company, 1929.